COMEDY WILDLIFE

PHOTOGRAPHY AWARDS
VOL 2

Published by 535
An imprint of Blink Publishing
3.08, The Plaza,
535 Kings Road,
Chelsea Harbour,
London, SW10 0SZ

www.blinkpublishing.co.uk

facebook.com/blinkpublishing
twitter.com/blinkpublishing

Hardback – 978-1-7887-0055-9
Ebook – 978-1-7887-0056-6

A CIP catalogue of this book is available from the British Library.

Designed by Envy Design
Printed and bound by Levent in Turkey

3 5 7 9 10 8 6 4 2

Blink Publishing is an imprint of Bonnier Books UK
www.bonnierbooks.co.uk

COMEDY WILDLIFE PHOTOGRAPHY AWARDS

VOL.2

CREATED BY
PAUL JOYNSON-HICKS AND TOM SULLAM

535

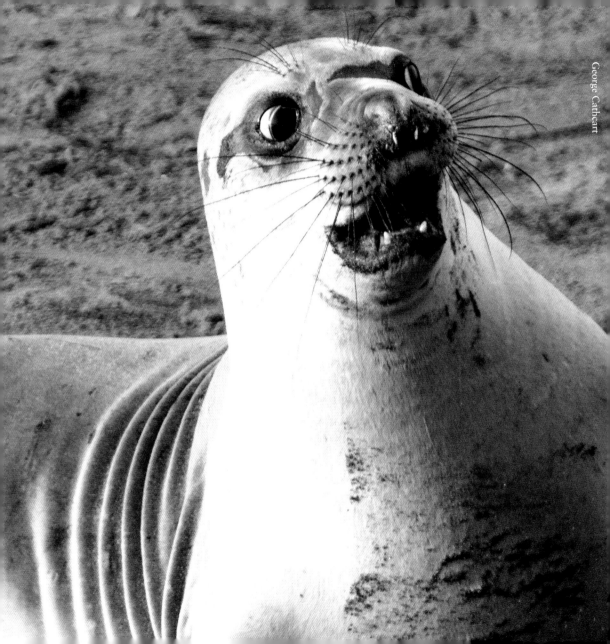

FOREWORD

BY KATE HUMBLE

Never work with children and animals – so the saying goes. Well I've been ignoring 50% of that advice for most of my working life and wouldn't have it any other way. Working with animals – whether domesticated or wild – is often challenging, occasionally infuriating, but never, ever boring. And even our most familiar, common or garden species have the capacity to surprise and delight.

For a decade I presented a live television series that followed the fortunes of some of Britain's best loved birds, mammals, amphibians and insects throughout the Spring. Spring is a time of courtship, of flirting and fighting, posturing and posing, sex, birth and death. It is more dramatic, more edge-of-the seat than any soap opera, and it is also much, much funnier. Over the years we were royally entertained by the antics of badgers behaving badly, ducklings leaping out of trees, the couldn't-be-less romantic sexual exploits of mating frogs. So when wildlife photographer Paul Joynson-Hicks first talked to me about the idea of doing a comedy wildlife photography competition, I couldn't believe it hadn't been done before. Like all the best ideas, it seemed so obvious.

I've been one of the judges of the Comedy Wildlife Photography Awards since its inception and the awards night is an evening I look forward to every year. The sheer variety of images captures all aspects of the animal kingdom, from the very small, to the enormous, from the wonderful to the downright weird. And those images come from all over the world and from every habitat, from forest to wetland, desert to icy tundra, mountains to the seas. As well as being great fun, the evening is a reminder, should we ever need one, of just what a magnificent planet we live on and what amazing inhabitants we share it with. So the fact that the Awards work in partnership with The Born Free Foundation, helping raise awareness and money for conservation that supports both people and wildlife, makes it all the more worthwhile being involved.

This book encapsulates all the things I love about the Comedy Wildlife Photography Awards. It is a celebration of the whims and wonders of the natural world, the unpredictable nature of nature. It proves that spending time outside, in the natural world, just watching and listening, can allow you to witness unforgettable moments. And not only that, it is a collection of truly beautiful photographs of an extraordinarily high standard (they have been judged against many thousands of images that were submitted), that are also properly, rib-ticklingly funny. Enjoy it!

Kate Humble

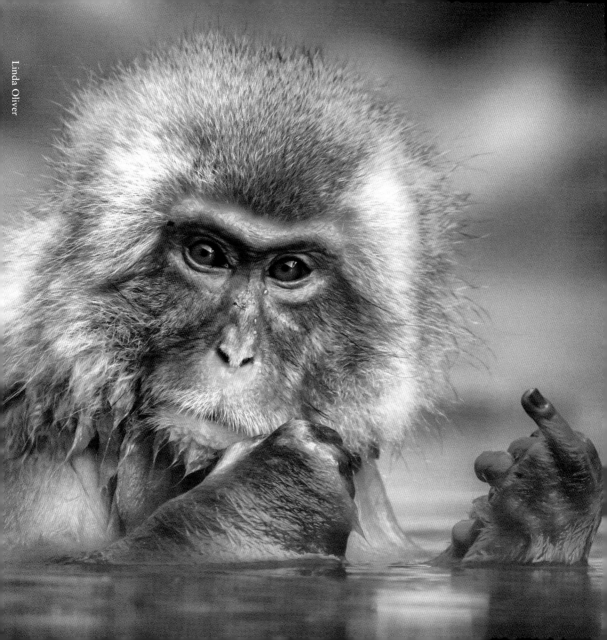

INTRODUCTION

Welcome to our second book! We would love to tell you that it has been a roller-coaster ride this year, that we've barely had a chance to sit down and have a cup of tea, that things have really been ridiculously busy since the first book was released… so we will tell you that. It has been a truly thrilling year, which has culminated with some absolutely fantastic images from the 2018 competition.

One of the most satisfying aspects of this year's competition has been the breadth of species that were photographed. There are some animals that never fail to provide entertainment, and we certainly do not tire of seeing the same animals in hilarious situations. But it is also very uplifting to see images of species that we have not seen entered before – dancing Komodo Dragons, shy Kingfishers, adolescent Moose (no idea if that is the plural or not. Mice maybe?) and embarrassed Lemurs, to name but a few. It reminds us that there really is so much out there that we just do not experience. Thanks to the photographers that enter this competition, we get to see bits of the world that we would not normally see.

Along the way we have made some great new friends, with the fantastic team at Affinity joining our own less fantastic team (of two) along with Spectrum Photographic whose printing was the reason for such a great exhibition. Our regular supporters stayed with us, for which we are very grateful (Alex Walkers Serian – who donate the sensational winning prize of a safari in East Africa, Think Tank, Amazing Internet and obviously The Born Free Foundation) – all staying with us and supporting the main reason we exist. That is, to promote and raise global awareness of wildlife. Sadly, every year that we introduce a new book, we will have to include the words 'now more than ever' because wildlife and its habitat is facing increasingly difficult times. This book serves to highlight the animals that live on earth alongside us. The more we can all do to reduce our impact on the rest of the world then the better. And by buying this book you directly support The Born Free Foundation, who work tirelessly to help and promote wildlife conservation. So thank you to you!

This year's book combines the brilliant finalists from 2017 with the 2018 winners and finalists. We think, and hope (and secretly assume), that you will enjoy these as much as we have. As ever we are utterly grateful to all those that continue to hold our hand through the numerous hurdles we encounter on a daily basis. Running a competition seems simple at first, and quite possibly is simple, but we are primarily photographers, so even the simplest tasks associated with administration take on mountainous proportions (no offence to all other photographers). So thank you to Natalie Galustian, to Blink Publishing and particularly Joel Simons, to Michelle Wood, to all our sponsors, to our families and to our friends, even the ones that have shown little/no interest in this. Most of all, thanks to you for supporting us.

Paul and Tom
www.comedywildlifephoto.com

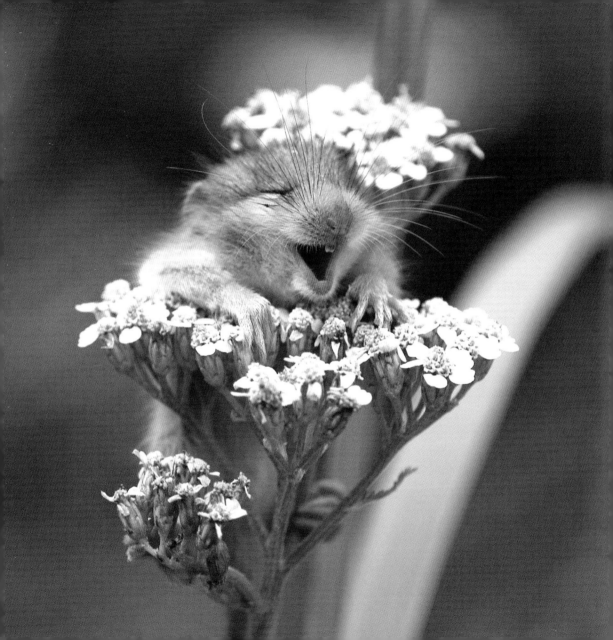

ANIMAL: Common Dormouse

LOCATION: ITALY

A baby dormouse laughing on a yarrow flower. 'I was hiking on a mountain close to my home town when I heard a strange squeaking from the woods and I found this cute baby dormouse on the top of a yarrow flower! I took just one shot and amazed, I saw this picture on the monitor of my camera!'

PHOTOGRAPHER: Andrea Zampatti

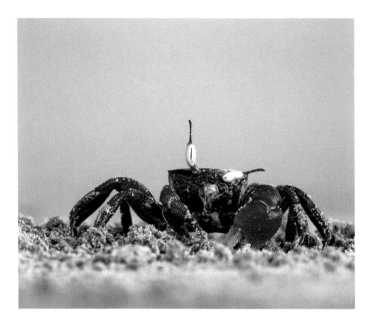

ANIMAL: Red Ghost Crab
LOCATION: KOLKATA, INDIA
A scuttling ghost crab keeps an eye out for predators.
PHOTOGRAPHER: Arkaprava Ghosh

ANIMAL: Red Kangaroo
LOCATION: FOWLERS GAP RESEARCH STATION, NSW, AUSTRALIA
Wild red kangaroo in the outback. 'These animals are most active in the early morning. And the morning is the best time for the martial arts training!'
PHOTOGRAPHER: Andrey Giljov

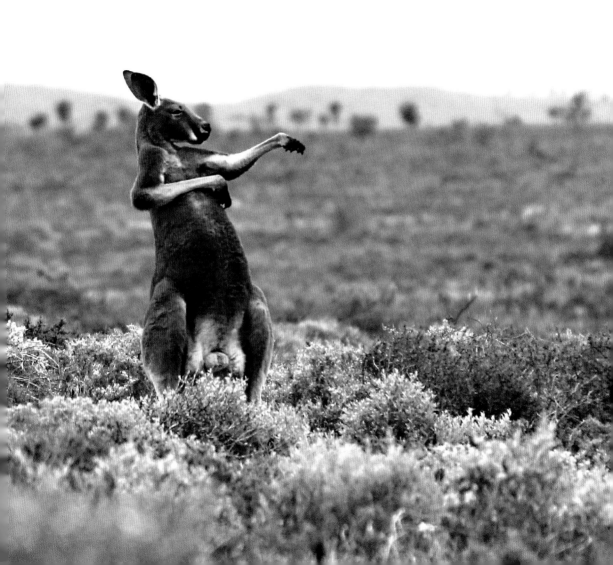

ANIMAL: Unidentified Caterpillar

LOCATION: HONG KONG

The very hungry caterpillar needs some help finding directions
to the tastiest leaves in town.

PHOTOGRAPHER: Aster Leung

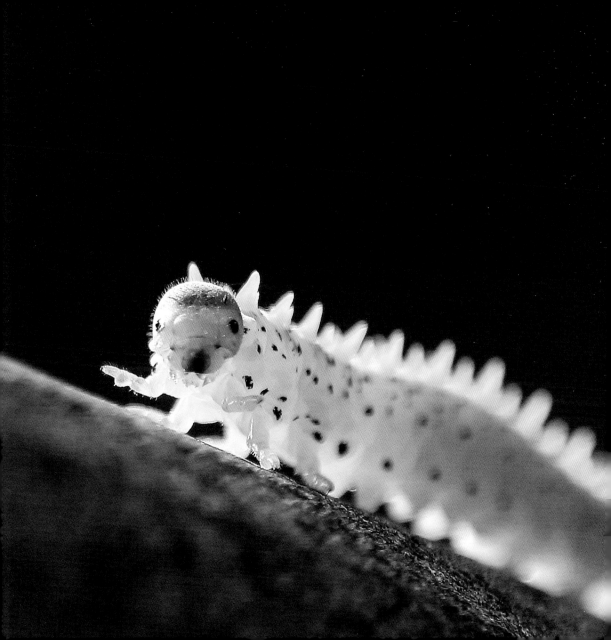

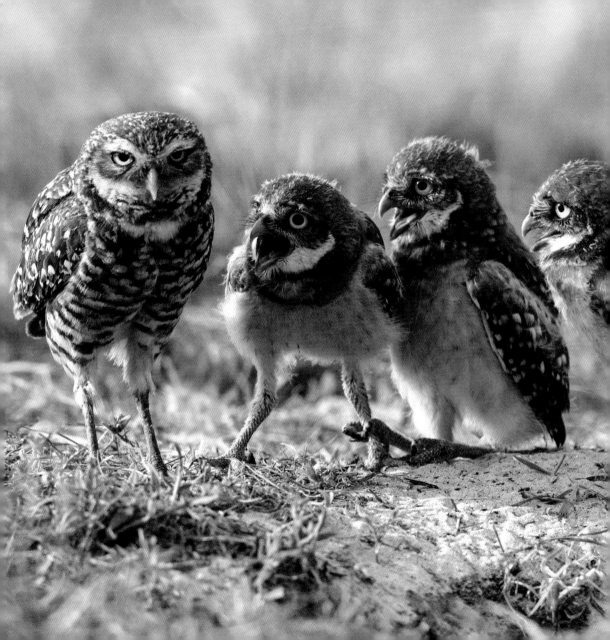

ANIMALS: Burrowing Owls

LOCATION: FLORIDA, USA

Something tells me this babysitting burrowing owl has heard
Knock knock. Who's there? Twit? Twit-who? before…

PHOTOGRAPHER: Barb D'Arpino

ANIMALS: Brown Bears

LOCATION: HARGHITA, ROMANIA

I think this might be what Baloo was really singing about in the Bare Necessities...

PHOTOGRAPHER: Bence Mate

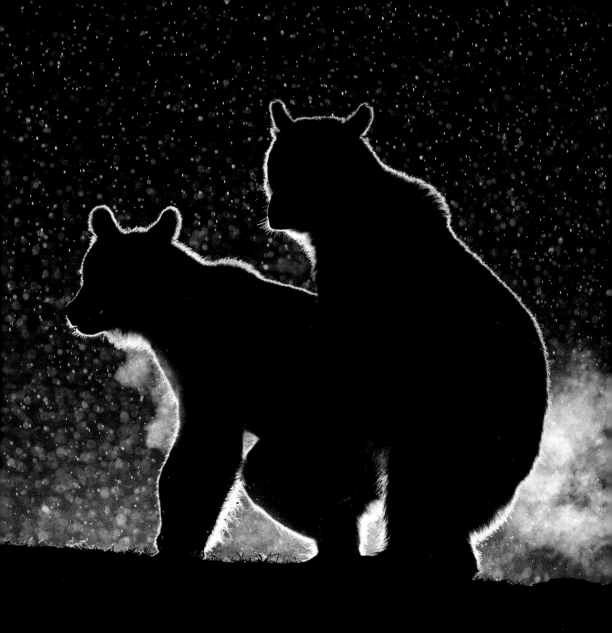

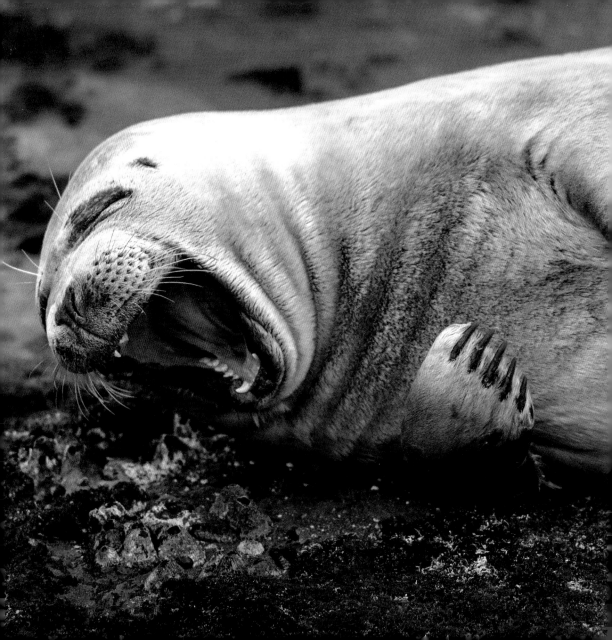

ANIMAL: Harbour Seal

LOCATION: SAN DIEGO, USA

This harbour seal has just found a sticker with 'Do not consume if seal is broken' written on it.

PHOTOGRAPHER: Brian Valente

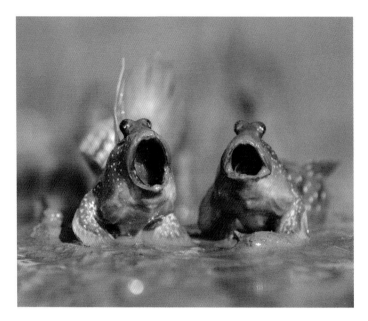

ANIMALS: Mudskippers
LOCATION: KRABI, THAILAND
Mudskipper's Got Talent.
PHOTOGRAPHER: Daniel Trim

ANIMAL: Kamchatka Bear
LOCATION: KAMCHATKA, RUSSIA
'Look, I've told you already, President Putin didn't ride me,' insists
this camera-shy Kamchatka bear.
PHOTOGRAPHER: Budkov Denis

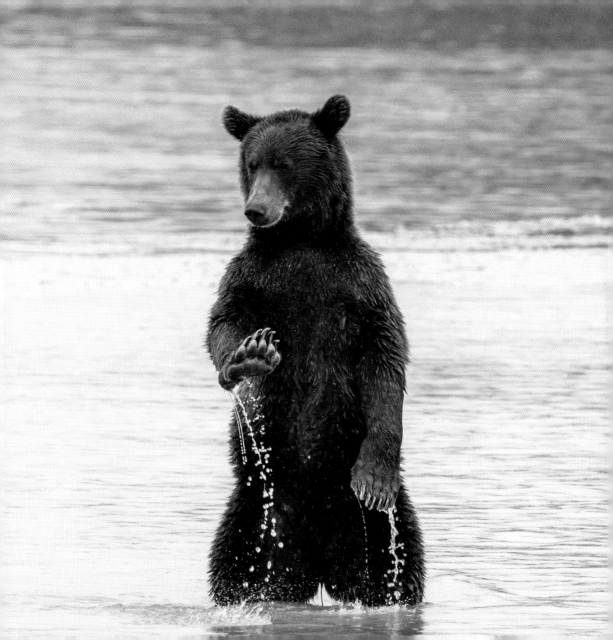

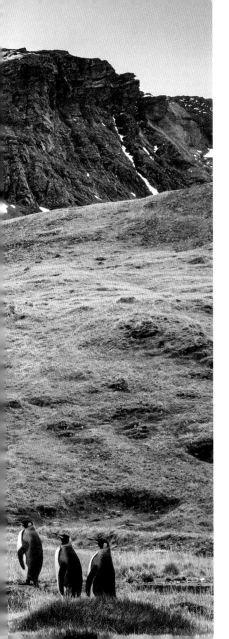

ANIMALS: King Penguins

LOCATION: GRYTVIKEN, SOUTH GEORGIA

'Well, no one can say we're not wearing our Sunday Best when we attend church,' says the leader of this king penguin group.

PHOTOGRAPHER: Carl Henry

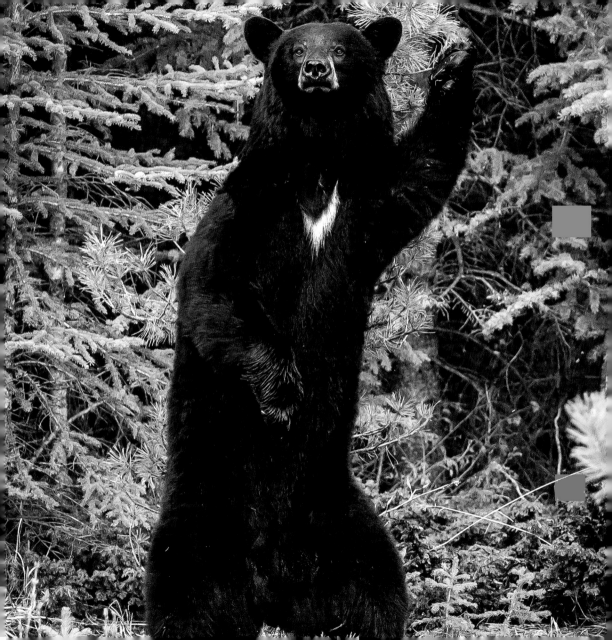

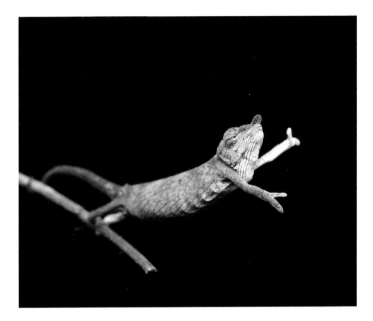

ANIMAL: Nose-horned Chameleon
LOCATION: ANDASIBE, MADAGASCAR
This chameleon conductor takes a bow.
PHOTOGRAPHER: Jasmine Vink

ANIMAL: Black Bear
LOCATION: JASPER, CANADA
I suspect that this black bear has seen *Saturday Night Fever* on more
than one occasion.
PHOTOGRAPHER: Christopher Martin

ANIMALS: Polar Bears

LOCATION: MANITOBA, CANADA

A baby bear bums a ride.

PHOTOGRAPHER: Daisy Gilardini

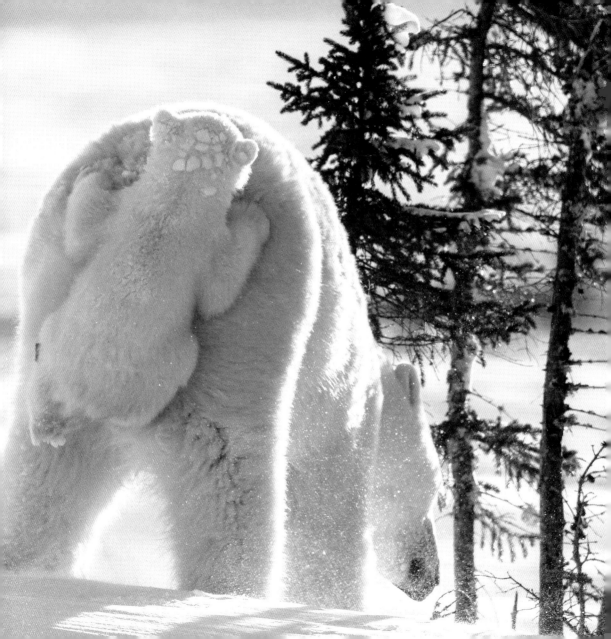

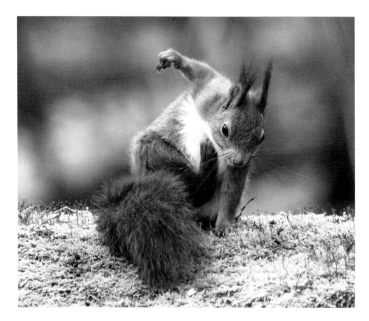

ANIMAL: Red Squirrel
LOCATION: GOTHENBERG, SWEDEN
Super Squirrel fighting crime like a moss.
PHOTOGRAPHER: Johnny Kaapa

ANIMALS: Burrowing Owlets
LOCATION: CALIFORNIA, USA
Can you two get a room already!
PHOTOGRAPHER: Melissa Usrey

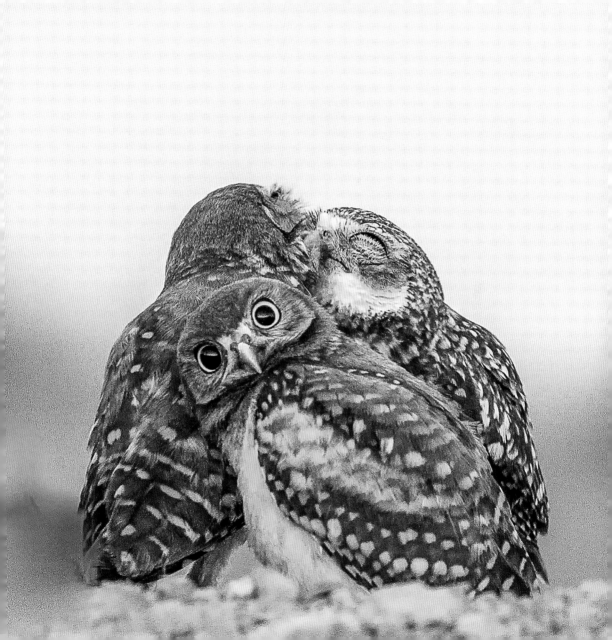

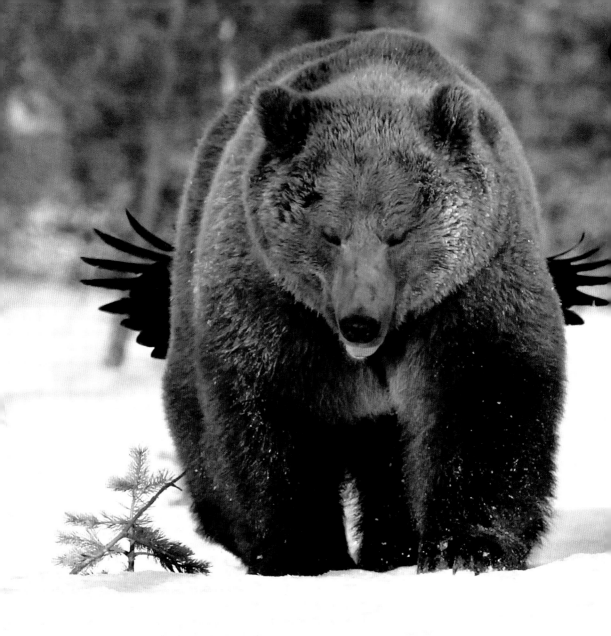

ANIMALS: Brown Bear and Raven

LOCATION: KUHMO, FINLAND

A grizzly bear begins to regret his choice of toilet paper.

PHOTOGRAPHER: Esa Ringbom

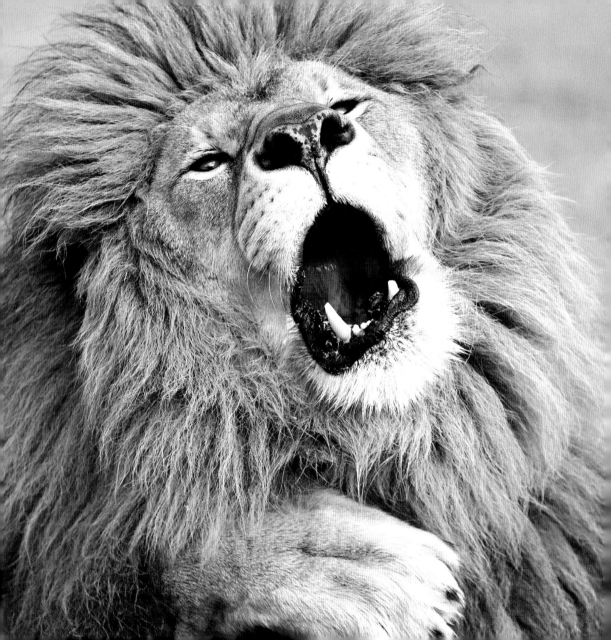

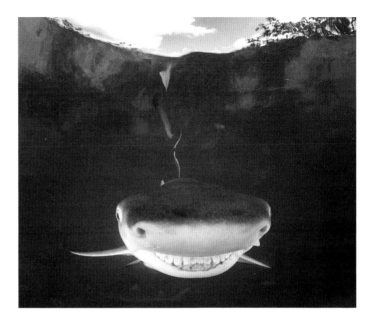

ANIMAL: Lemon Shark
LOCATION: BIMINI, THE BAHAMAS
This baby lemon shark has mastered the art of taking a good profile pic.
PHOTOGRAPHER: Eugene Kitsios

ANIMAL: East African Lion
LOCATION: TANZANIA, AFRICA
What's the difference between a lion with toothache and a rainstorm? One pours with rain...
PHOTOGRAPHER: Gill Merritt

ANIMALS: Elephant Seals
LOCATION: CALIFORNIA, USA
Not the sort of reaction this elephant
seal hoped for from his party trick.
PHOTOGRAPHER: George Cathcart

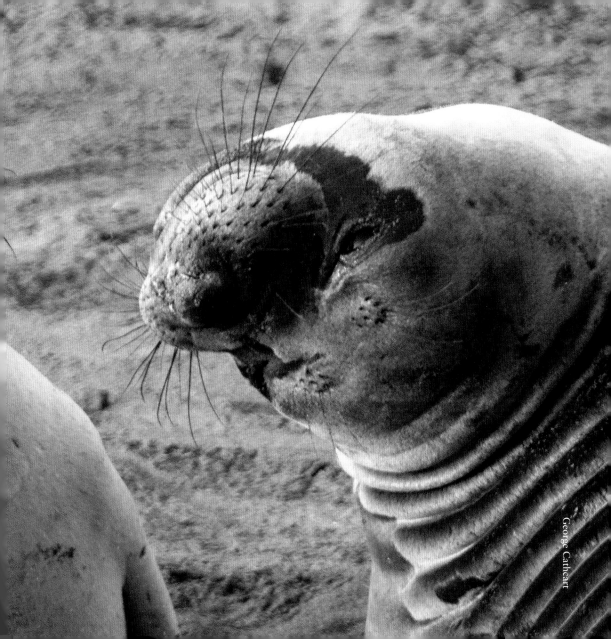

George Cathcart

ANIMALS: Giraffes

LOCATION: KENYA, AFRICA

Well, plane trees are actually part of a giraffe's diet.

PHOTOGRAPHER: Graeme Guy

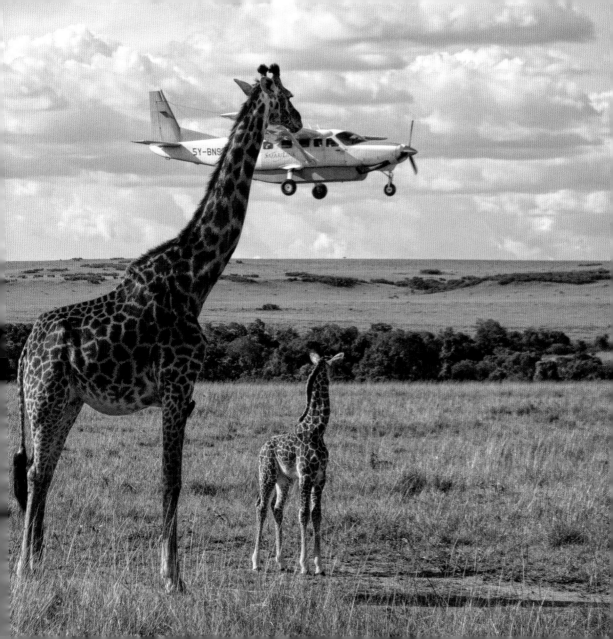

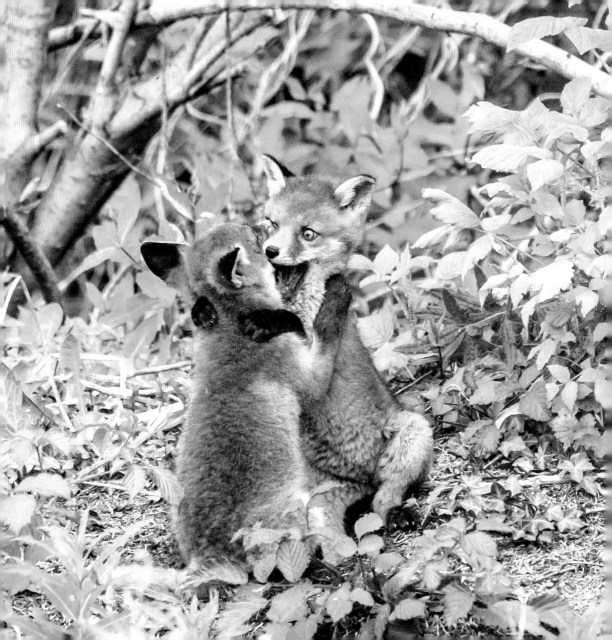

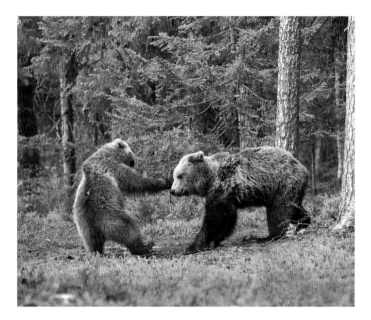

ANIMALS: Brown Bears

LOCATION: SUOMUSSALMI, FINLAND

He's spent 270 days kicking me in the womb, and the thanks I get? A punch in the face.

PHOTOGRAPHER: Hannele Kaihola

ANIMALS: Red Foxes

LOCATION: CO. MEATH, IRELAND

You'd think that this pair would be better at the foxtrot.

PHOTOGRAPHER: John Sheridan

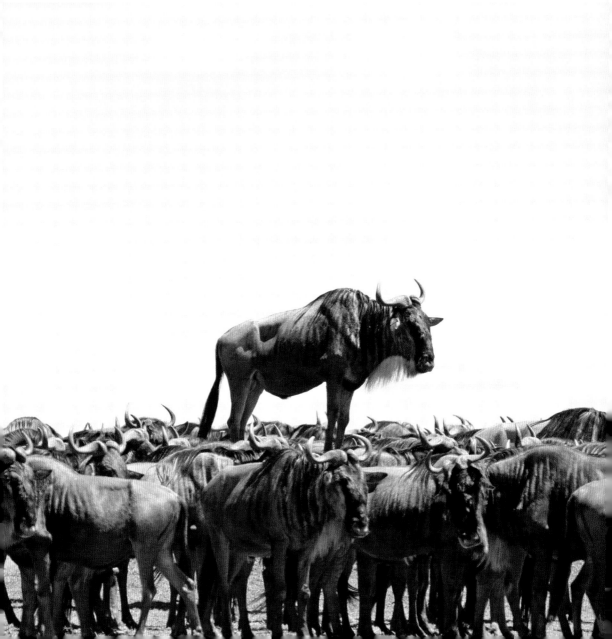

ANIMALS: Blue Wildebeest

LOCATION: MASAI MARA, KENYA

His powers of levitation earned this blue wildebeest the
nickname 'The David Blaine of the Masai Mara'.

PHOTOGRAPHER: Jean-Jacques-Alcalay

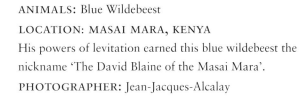

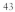

ANIMAL: Mountain Gorilla

LOCATION: VIRUNGA, RWANDA

This mountain gorilla has acquired the nickname 'Meh'.
Can't imagine why...

PHOTOGRAPHER: Josef Friedhuber

ANIMALS: Wigeons

LOCATION: PRESTON, UK

One of these wigeons is under investigation for using performance-enhancing drugs.

PHOTOGRAPHER: John Threlfall

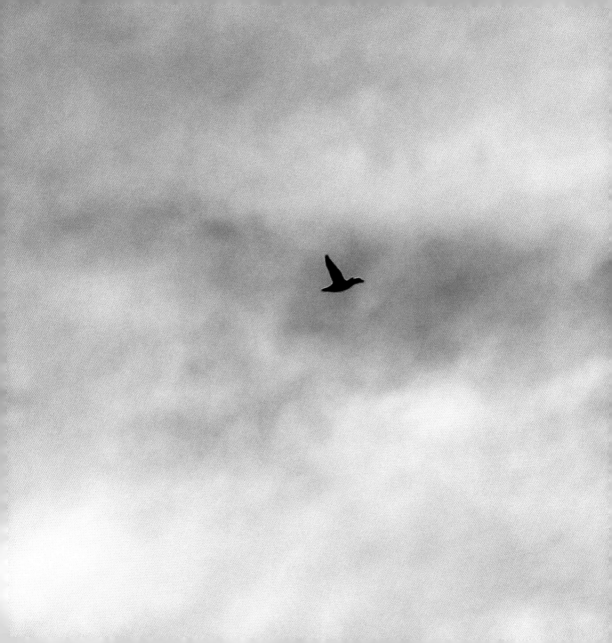

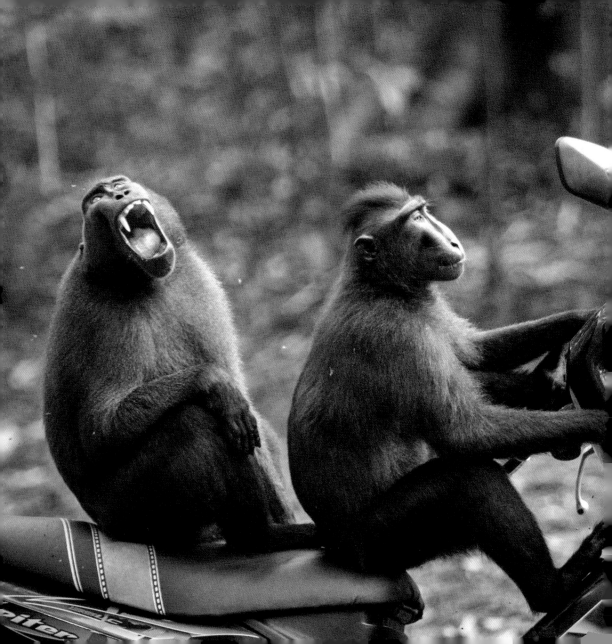

ANIMALS: Celebes Macaques

LOCATION: SULAWESI, INDONESIA

These endangered Celebes macaques are the latest addition to the staff at Deliveroo.

PHOTOGRAPHER: Katy Laveck Foster

ANIMAL: Japanese Macaques
LOCATION: NAKANO, JAPAN
Japanese macaques regularly bathe in hot springs in the cold winter months. But they don't take kindly to being photographed in the nude.
PHOTOGRAPHER: Linda Oliver

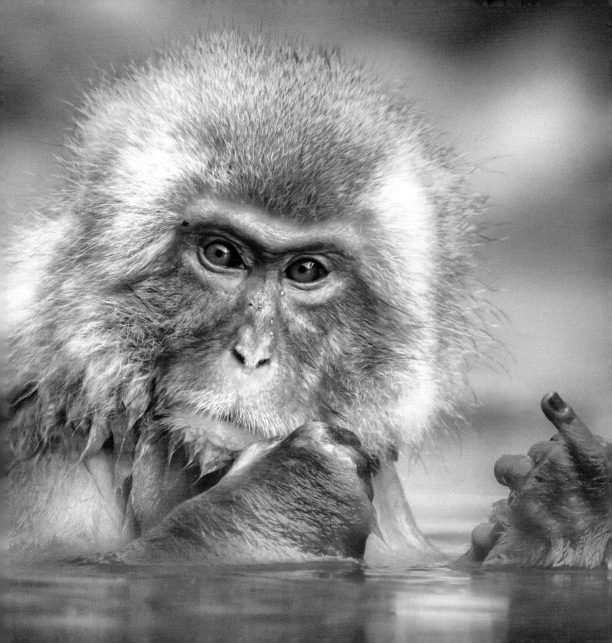

ANIMALS: Brown Bears

LOCATION: MARTINSELKONEN, FINLAND

Can a mama brown bear get five minutes peace!

PHOTOGRAPHER: Melissa Nolan

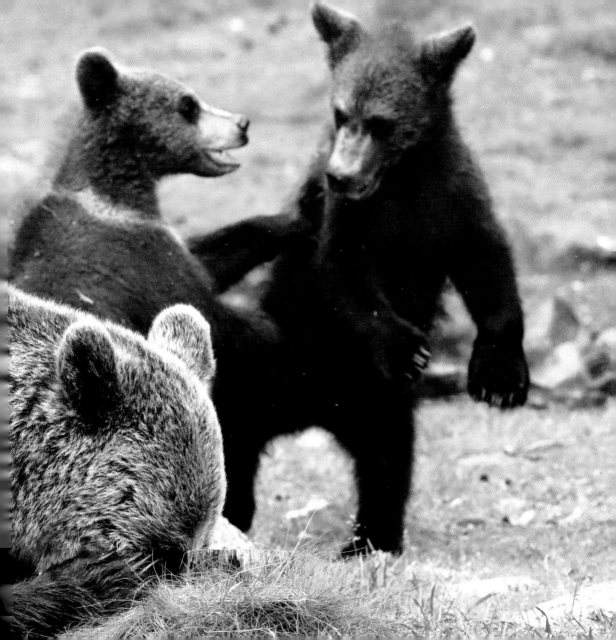

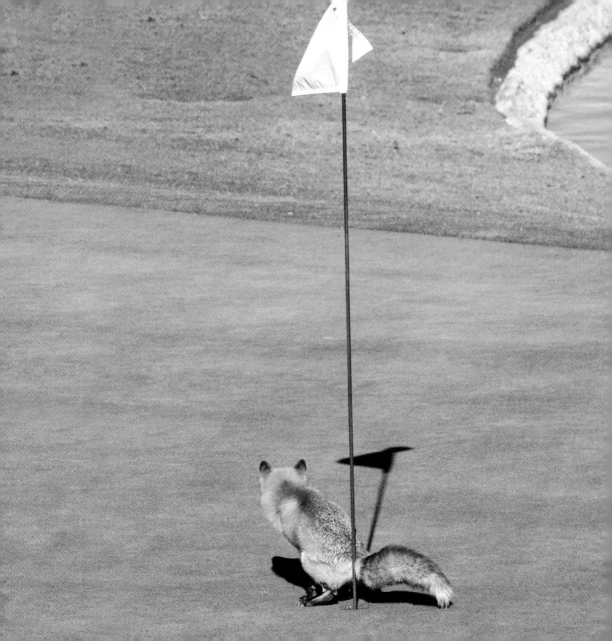

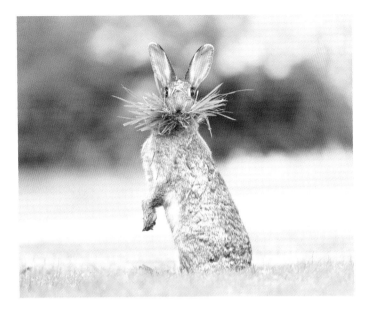

ANIMAL: European Rabbit
LOCATION: FLANDERS, BELGIUM
A moustachioed rabbit proves that collecting nest material doesn't have to be a chore.
PHOTOGRAPHER: Olivier Colle

ANIMAL: Red Fox
LOCATION: CALIFORNIA, USA
A red fox pictured on hole number two...
PHOTOGRAPHER: Douglas Croft

ANIMAL: Sea Otter

LOCATION: CALIFORNIA, USA

This sea otter couldn't be more happy with her seaweed exfoliation treatment.

PHOTOGRAPHER: Penny Palmer

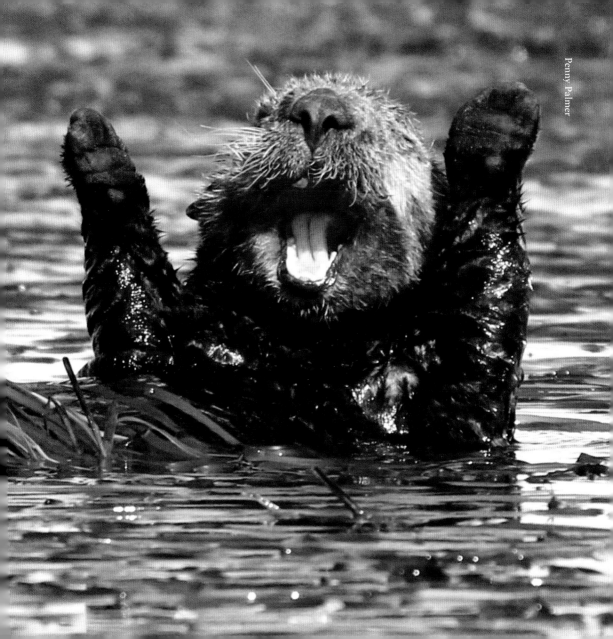

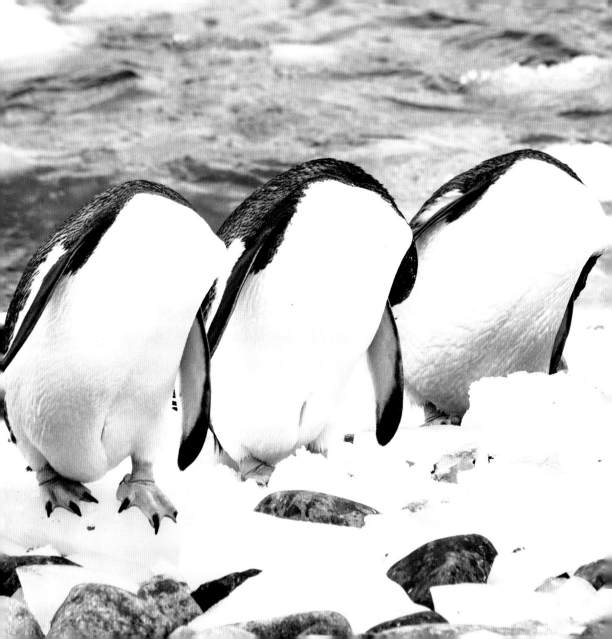

ANIMALS: Gentoo Penguins

LOCATION: CUVERVILLE ISLAND, ANTARCTICA

A new species of penguin was discovered in Antarctica last summer!

PHOTOGRAPHER: Monique Joris

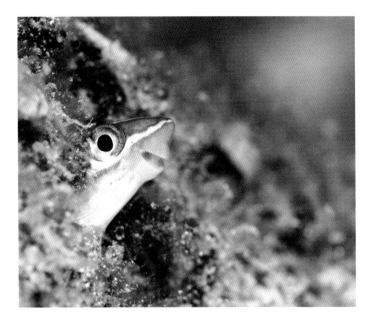

ANIMAL: (unidentified fish)
LOCATION: SIPADAN, MALAYSIA
'And this is the front garden,' says a house-proud little fish.
PHOTOGRAPHER: Tanakit Suwanyangyaun

ANIMAL: Chameleon
LOCATION: RAMAT GAN, ISRAEL
This little chameleon isn't quite getting the hang of hide and seek…
PHOTOGRAPHER: Nadav Begim

ANIMAL: Blue Wildebeest

LOCATION: MKHUZE PARK, SOUTH AFRICA

'Looks like the diet worked!' says this blue wildebeest.

PHOTOGRAPHER: Paulette Struckman

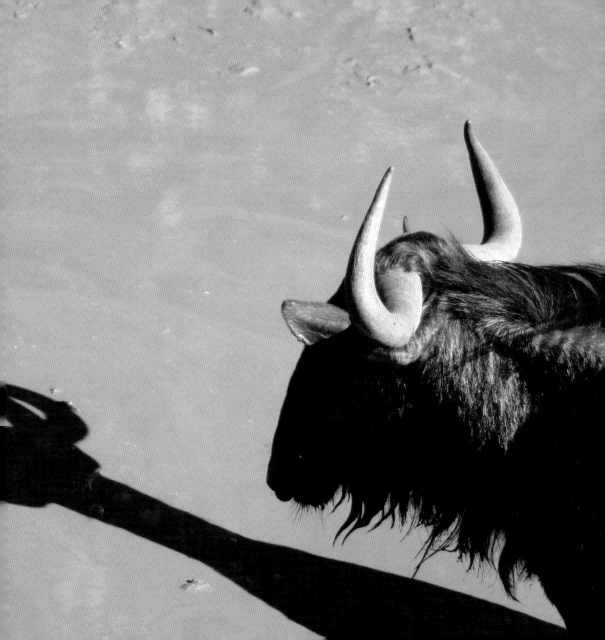

ANIMALS: King Penguins

LOCATION: FALKLAND ISLANDS

'Now you two clowns drop and give me 20!'

PHOTOGRAPHER: Miguel Illana

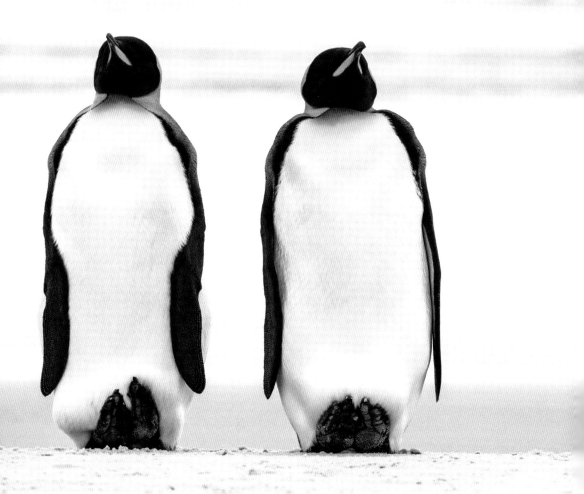

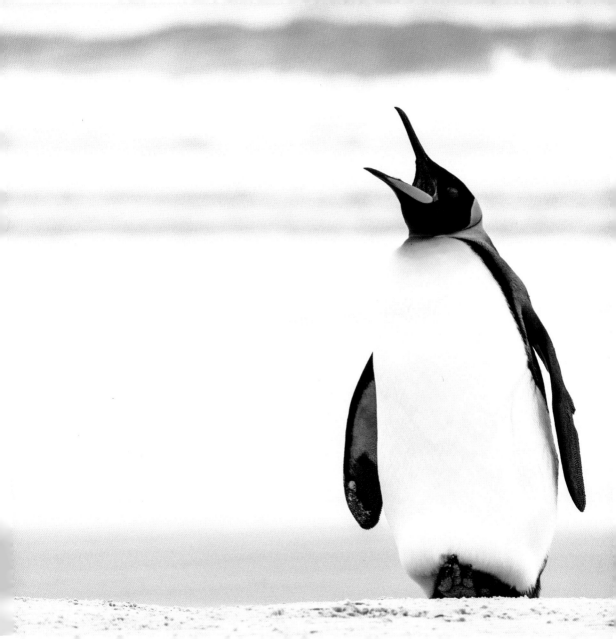

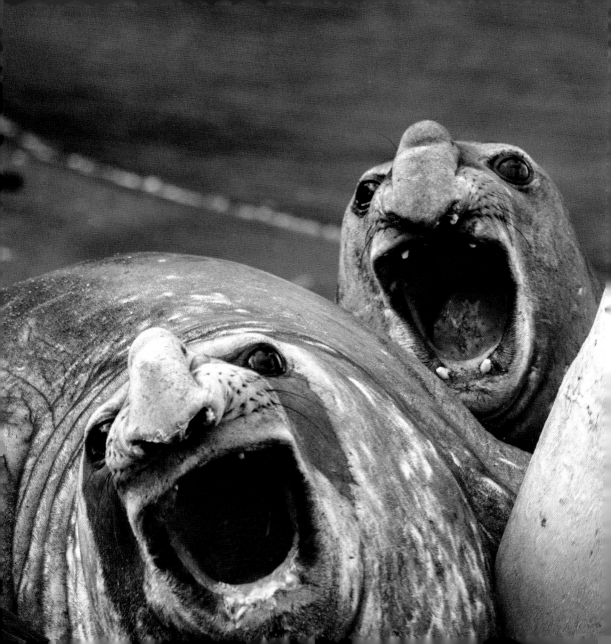

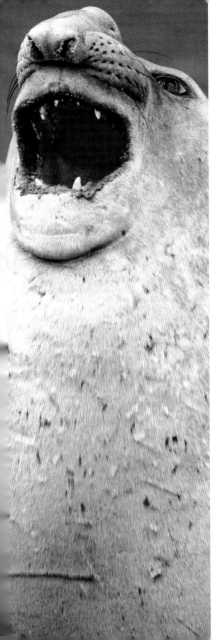

ANIMALS: Elephant Seals

LOCATION: SOUTH GEORGIA ISLAND

The three tenors of the elephant seal world.

PHOTOGRAPHER: Roie Galitz

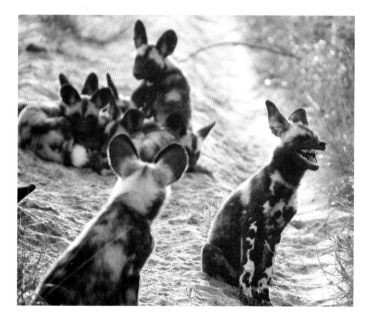

ANIMALS: African Wild Dogs
LOCATION: TEMBE ELEPHANT PARK, SOUTH AFRICA
And the funny thing was, I did actually eat his homework!
PHOTOGRAPHER: Tina Stehr

ANIMALS: Little Owls
LOCATION: OPUSZTASZER, HUNGARY
There were three on the branch and the little owl said 'A little help, here, people!'
PHOTOGRAPHER: Tibor Kercz

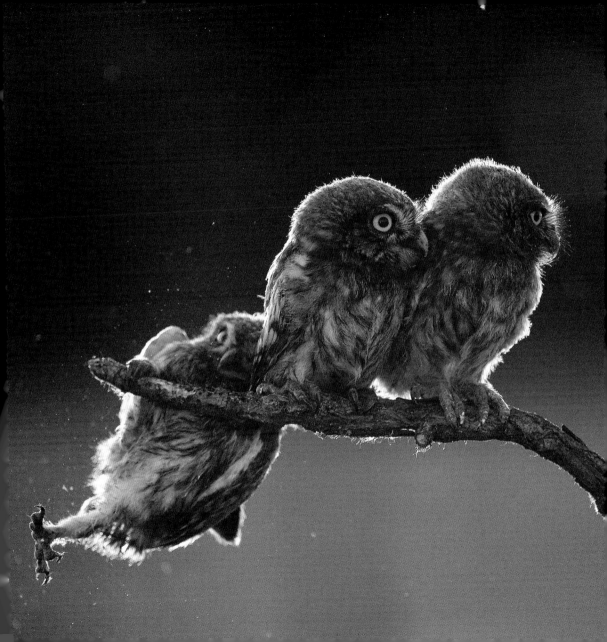

ANIMALS: Green Sea Turtle and Napoleon Maori Wrasse
LOCATION: GREAT BARRIER REEF, AUSTRALIA
'For the last time, I don't want to buy home insurance,'
says this irritated green sea turtle.
PHOTOGRAPHER: Troy Mayne

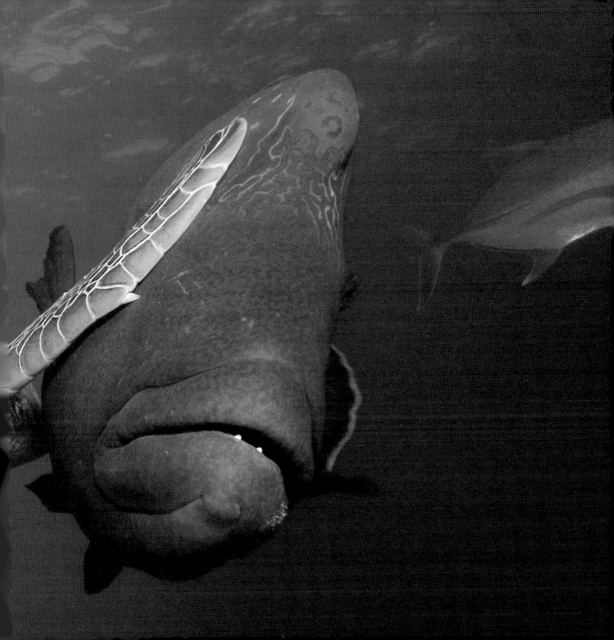

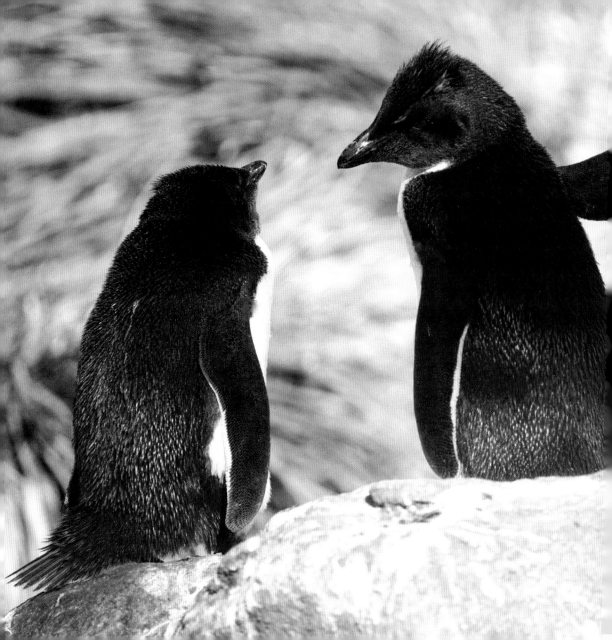

ANIMALS: Rockhopper Penguins

LOCATION: FALKLAND ISLANDS

Yes mate, you take a right at the beach, and watch out for the walrus pretending to be a boulder.

PHOTOGRAPHER: Achim Sterna

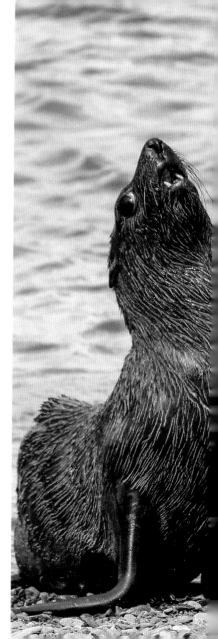

ANIMALS: King Penguins and Fur Seal

LOCATION: SOUTH GEORGIA ISLAND

I don't care what you've got to say about equal opportunities,
Mr Fur Seal – you can't join our penguin barber shop quartet.

PHOTOGRAPHER: Amy Kennedy

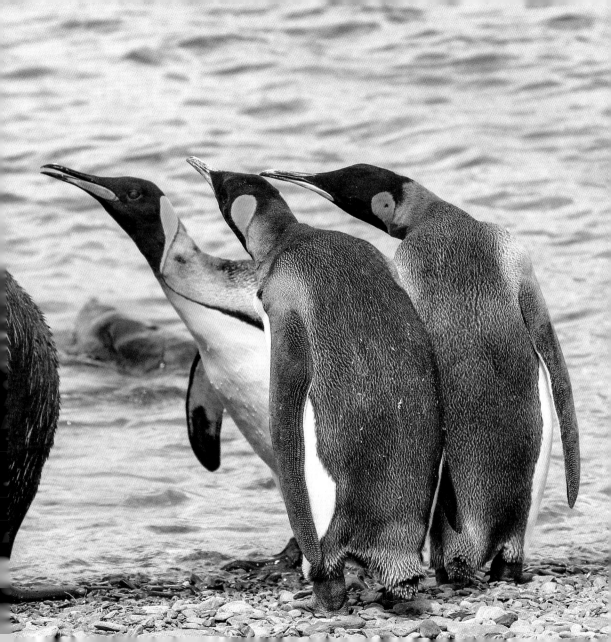

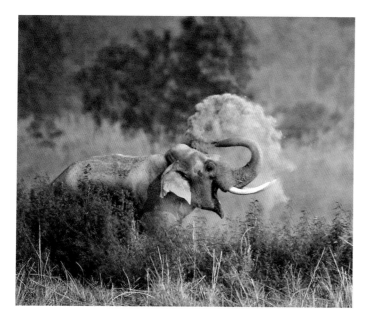

ANIMAL: Indian Elephant
LOCATION: UTTARAKHAND, INDIA
Nellie the elephant packed her trunk with dirt and mucked about.
PHOTOGRAPHER: Anup Deodhar

ANIMAL: Elephant Seal
LOCATION: SOUTH GEORGIA ISLAND
This mini golf hole was a little more lifelike than expected. And getting your ball back might take some time.
PHOTOGRAPHER: Amy Kennedy

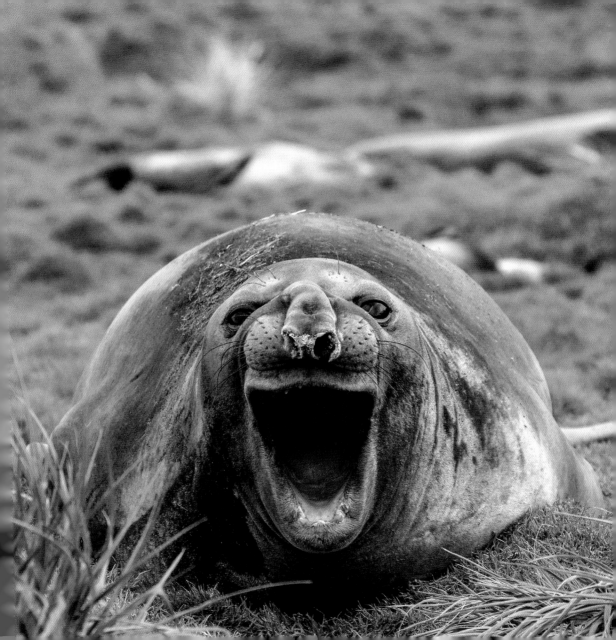

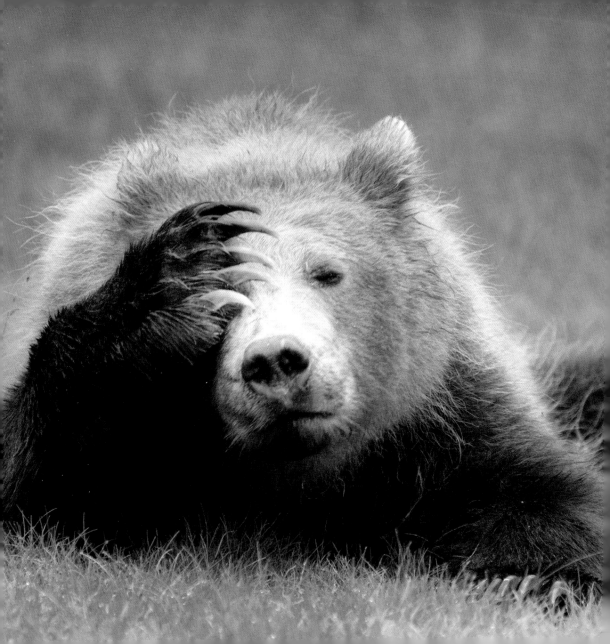

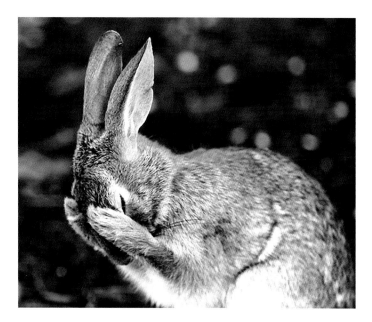

ANIMAL: Rabbit
LOCATION: WEST VIRGINIA, USA
I can't believe I really thought the grass was greener on the other side.
PHOTOGRAPHER: Daniel Friend

ANIMAL: Coastal Brown Bear
LOCATION: ALASKA, USA
Will someone please get me two Anadin and a glass of water?
PHOTOGRAPHER: Danielle D'Ermo

ANIMALS: Moose
LOCATION: WYOMING, USA
We are not amoosed.
PHOTOGRAPHER: Barney Koszalka

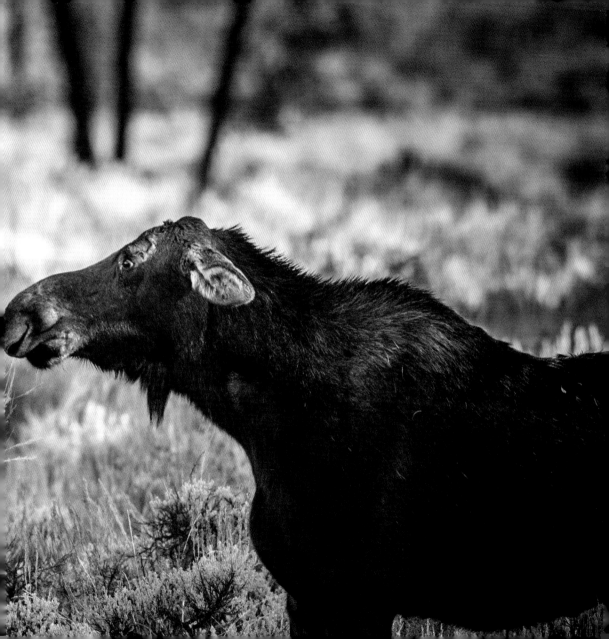

ANIMALS: Red Deer

LOCATION: RICHMOND, UK
So, it's slow, quick, quick, slow?

PHOTOGRAPHER: Bartek Olszewski

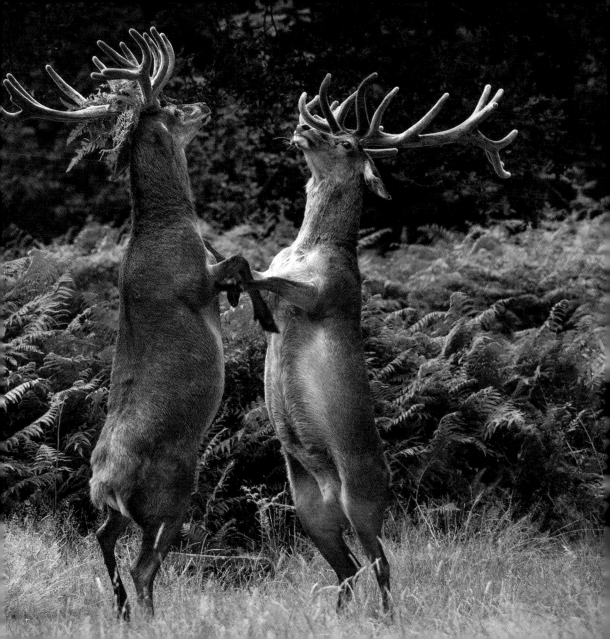

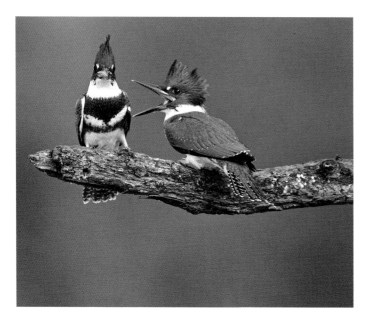

ANIMALS: Belted Kingfishers
LOCATION: MICHIGAN, USA
This isn't the 1950s. You can't just turn up late and expect dinner to be served!
PHOTOGRAPHER: Christopher Schlaf

ANIMAL: Kingfisher
LOCATION: HUELVA, SPAIN
This kingfisher has adopted a novel fish-hunting technique. 'If I can't see him, he can't see me.'
PHOTOGRAPHER: Antonio Medina

ANIMAL: Polar Bear

LOCATION: SVALBARD, NORWAY

Looks like he might be going with the (ice) flow.

PHOTOGRAPHER: Denise Dupras

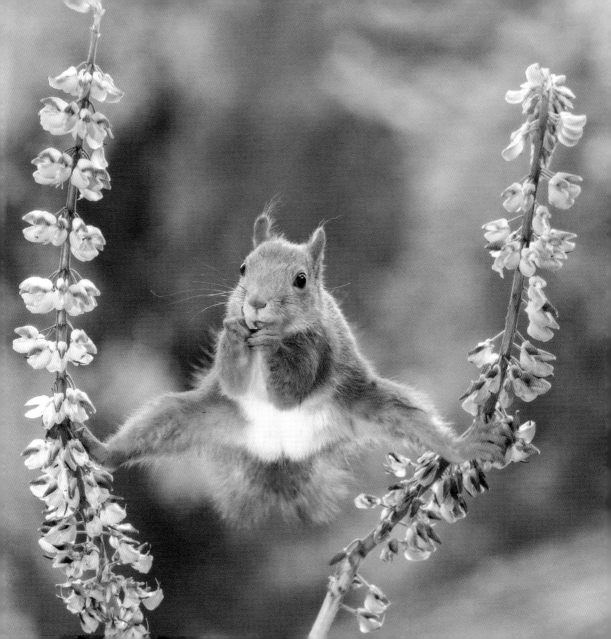

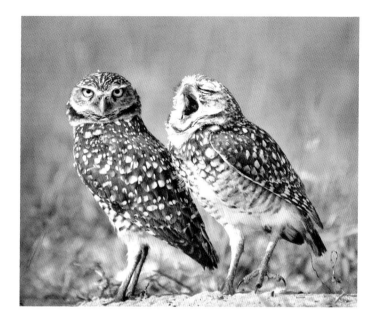

ANIMALS: Burrowing Owls
LOCATION: CAPE CORAL, FLORIDA
A telltale sign that this first date really isn't going so well.
PHOTOGRAPHER: Danielle D'Ermo

ANIMAL: Red Squirrel
LOCATION: RAGUNOA, SWEDEN
The prenatal classes for this female red squirrel are pretty intense.
PHOTOGRAPHER: Geert Weggen

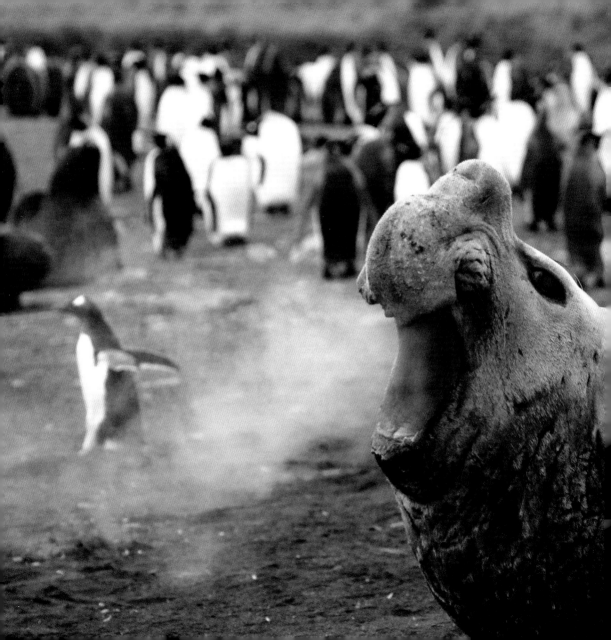

ANIMAL: Walrus and Penguins

LOCATION: SOUTH GEORGIA ISLAND
I'll huff and I'll puff and I'll blow out a penguin!

PHOTOGRAPHER: Jackie Downey

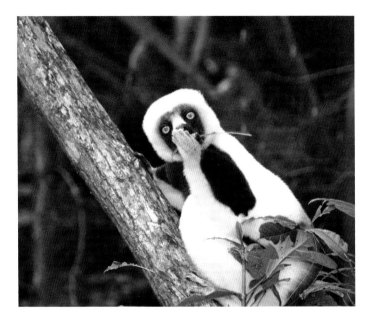

ANIMAL: Coquerel's Sifaka
LOCATION: MADAGASCAR
This endangered Coquerel's sifaka looks embarrassed at being rumbled breaking his 5:2 diet.
PHOTOGRAPHER: Jakob Strecker

ANIMAL: Moose
LOCATION: SOUTHERN ALBERTA, CANADA
Not a great time to be caught short in the woods.
PHOTOGRAPHER: Jamie Bussey

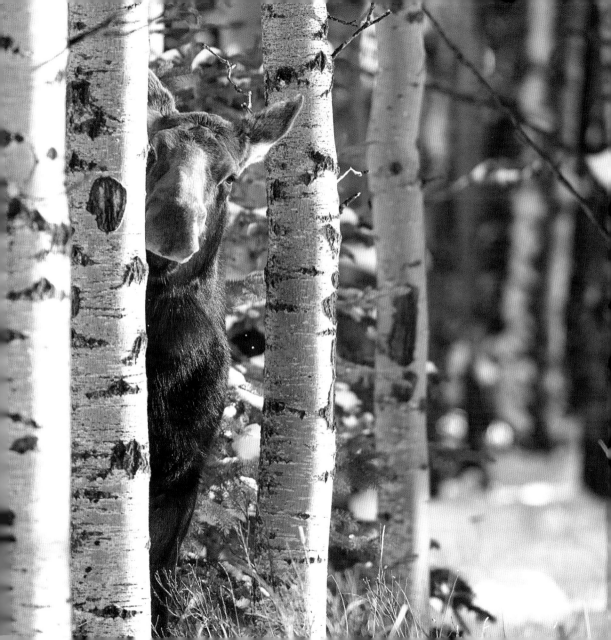

ANIMAL: Grizzly Bear

LOCATION: ALASKA, USA

This is what everyone thinks of when the Sat Nav says 'Bear right'.

PHOTOGRAPHER: Jonathan Irish

REMEMBER
STOP FOR BUSES
TURN ON HEADLIGHTS

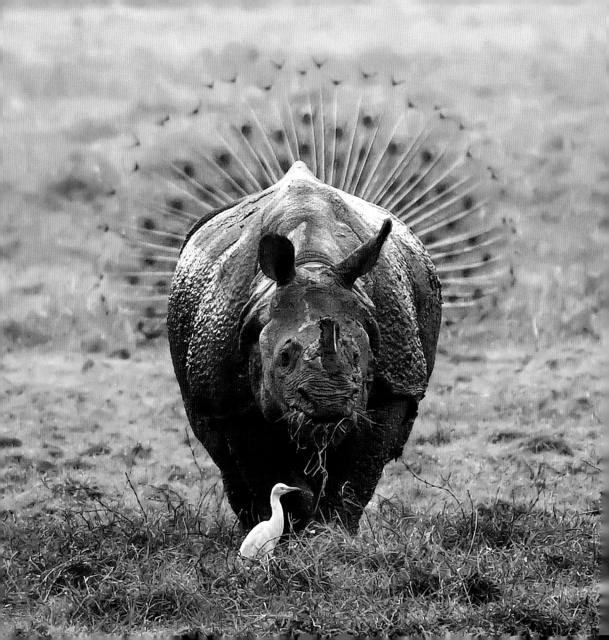

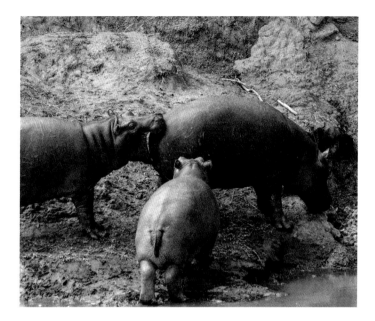

ANIMALS: Hippos

LOCATION: MASAI MARA, KENYA

Should have gone to Specsavers…

PHOTOGRAPHER: Michael Lane

ANIMAL: Indian Rhinoceros

LOCATION: BENGAL, INDIA

This Indian rhino has been auditioning for the role of Princess Odette in *Swan Lake*. Looks like her dance partner may struggle with some of the lifts though.

PHOTOGRAPHER: Kallol Mukherjee

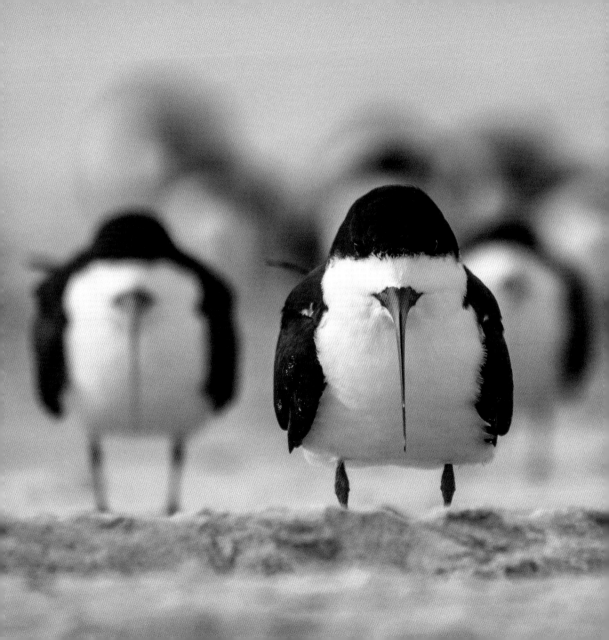

ANIMALS: Black Skimmers

LOCATION: LONG BEACH, NEW YORK, USA

A gang of black skimmers re-enact a famous scene from *Reservoir Dogs*

PHOTOGRAPHER: Ke Qiang Ruan

ANIMALS: Spotted Hyena and Vulture
LOCATION: OLARE MOTOROGI CONSERVANCY, KENYA
My mum thinks I'm a little angel!
PHOTOGRAPHER: Kevin Rooney

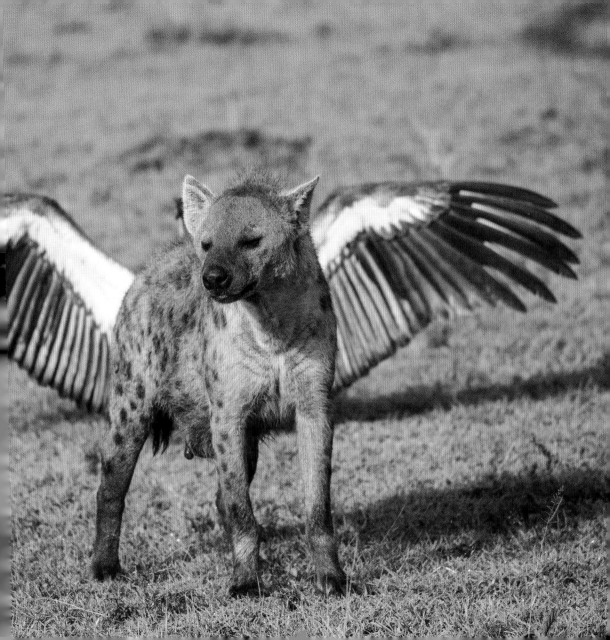

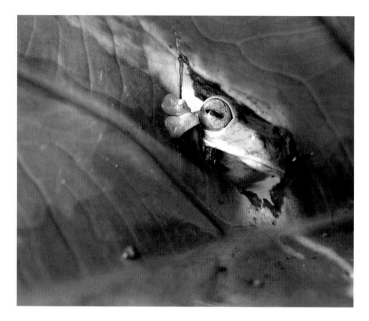

ANIMAL: (Unknown) Frog
LOCATION: TABALONG, INDONESIA
This curtain-twitching frog can't help but peek at what's going on next-door.
PHOTOGRAPHER: Muntazeri Abdi

ANIMALS: Polar Bears
LOCATION: CHURCHILL, CANADA
The new pair on *Dancing On Ice* may have a slight advantage over the competition.
PHOTOGRAPHER: Luca Venturi

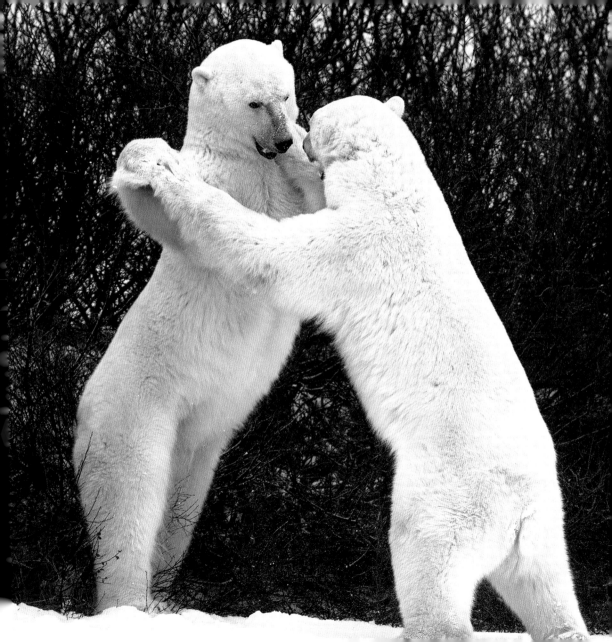

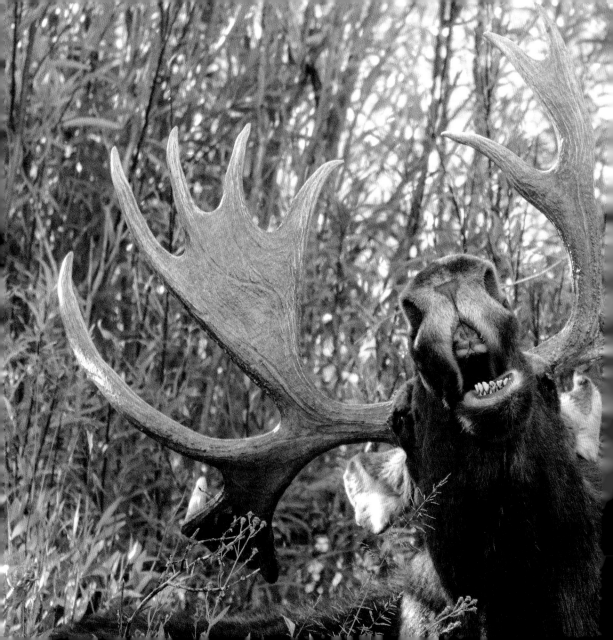

ANIMAL: Moose

LOCATION: GRAND TETON NATIONAL PARK, WYOMING, USA

The American moosical maestro belts out 'Oh what a beautiful morning'.

PHOTOGRAPHER: Mary Hone

ANIMALS: African Lions

LOCATION: KENYA

So let me get this straight. A friendly pack of
hyenas said they'd look after the dead zebra until
you got back? You mug.

PHOTOGRAPHER: Maureen Toft

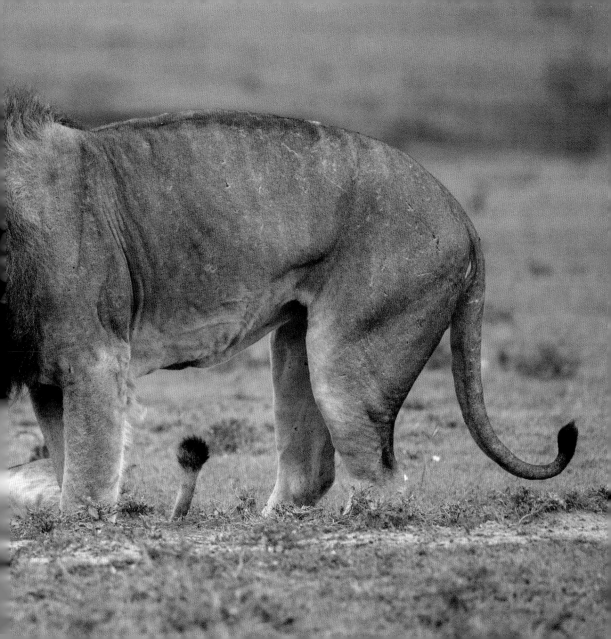

ANIMAL: Eastern Grey Squirrel
LOCATION: BRANDON, FLORIDA, USA
It wasn't me, honest – I didn't nick your nut!
PHOTOGRAPHER: Mary McGowan

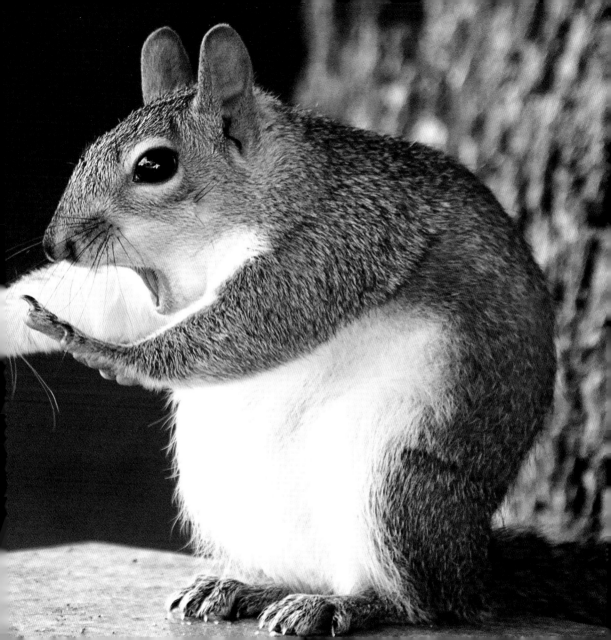

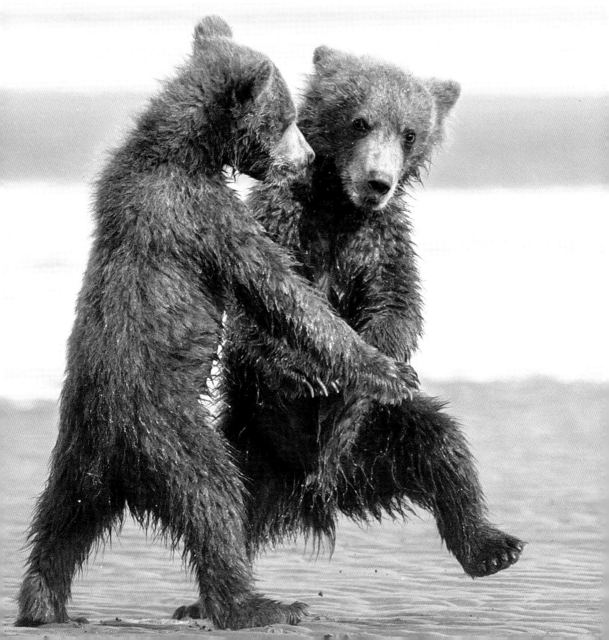

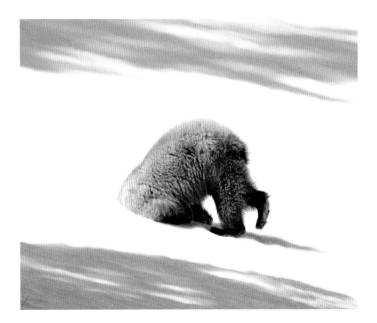

ANIMAL: Black Bear
LOCATION: YELLOWSTONE NATIONAL PARK, WYOMING, USA
This black bear adopts a novel approach to combat the picture-taking from tourists visiting Yellowstone National Park.
PHOTOGRAPHER: Patty Bauchman

ANIMALS: Coastal Brown Bears
LOCATION: ALASKA, USA
That's right, Rupert – you lead with your left foot!
PHOTOGRAPHER: Michael Watts

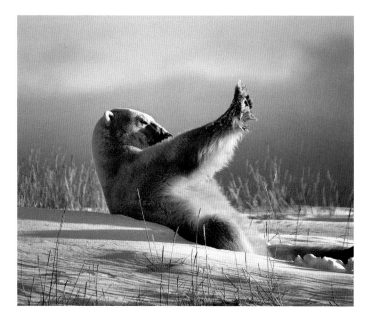

ANIMAL: Polar Bear
LOCATION: ARCTIC
Goodbye Mr Sun – see you tomorrow!
PHOTOGRAPHER: Qiusheng Hu

ANIMALS: African Lions
LOCATION: MASAI MARA, KENYA
And then Aslan said: 'Get lost, it's Narnia business.'
PHOTOGRAPHER: Muriel Vekemans

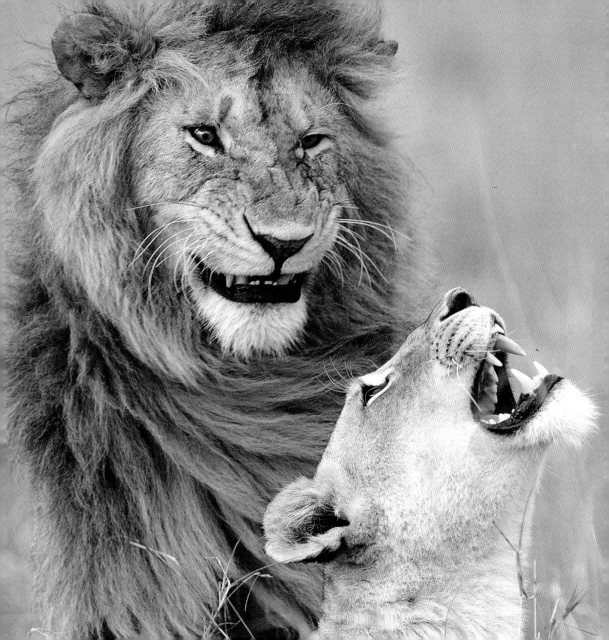

ANIMALS: Tree Swallow

LOCATION: ELIZABETH, COLORADO, USA

This handsome male tree swallow has really ruffled a few feathers since he's been in town.

PHOTOGRAPHER: Dawn Key

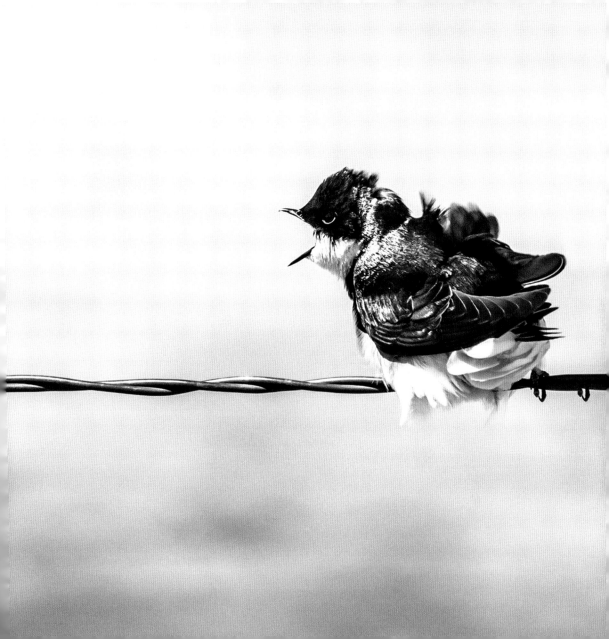

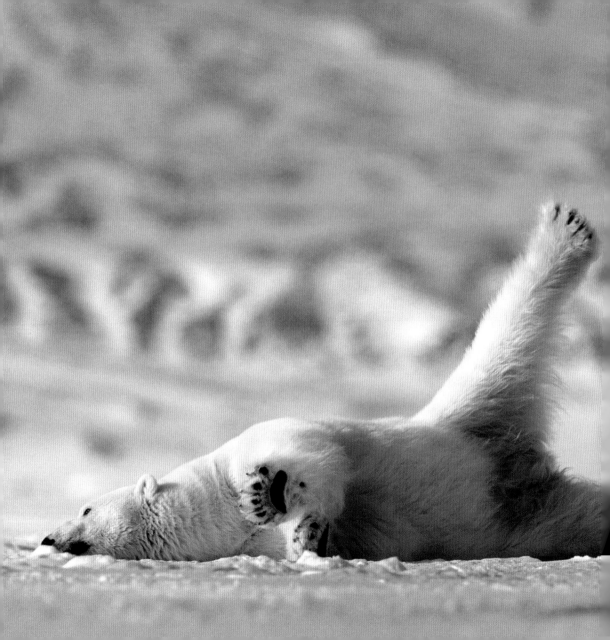

ANIMAL: Polar bear

LOCATION: SVALBARD, NORWAY

This polar bear hasn't quite mastered the side plank yet...

PHOTOGRAPHER: Roie Galitz

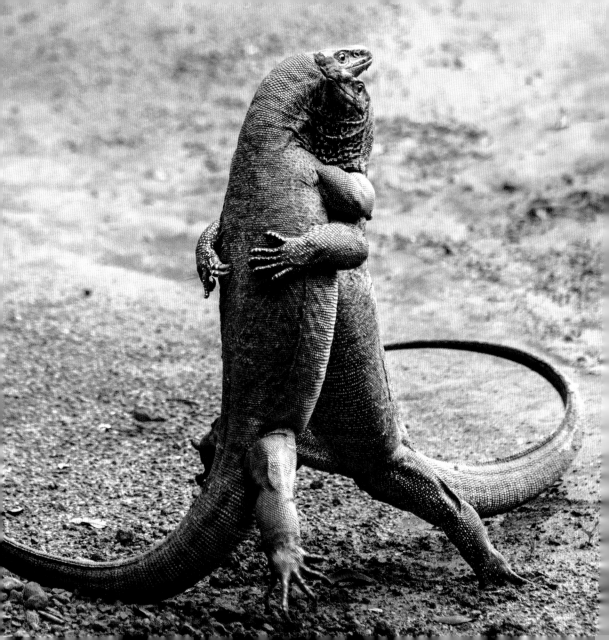

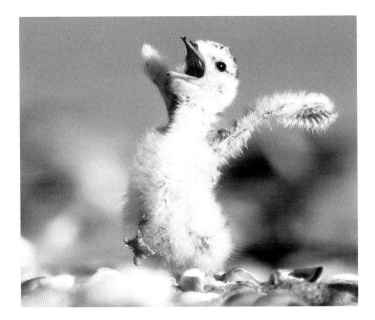

ANIMAL: Least Tern
LOCATION: *UNKNOWN*
They call this move the 'Chick-flick'.
PHOTOGRAPHER: Sarah Devlin

ANIMALS: Monitor Lizards
LOCATION: WILPATTU NATIONAL PARK, SRI LANKA
It's just so good to see you again!
PHOTOGRAPHER: Sergey Savvi

ANIMALS: Mudskippers

LOCATION: KRABI, THAILAND

Mudskippers are one of the few fish capable of breathing on land – a power that they seem to use solely to make out.

PHOTOGRAPHER: Sergey Savvi

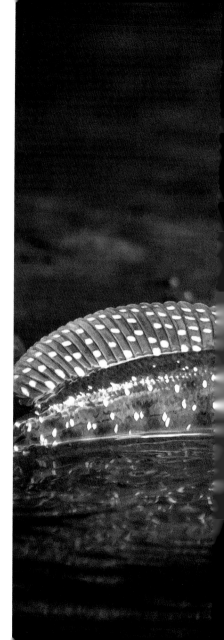

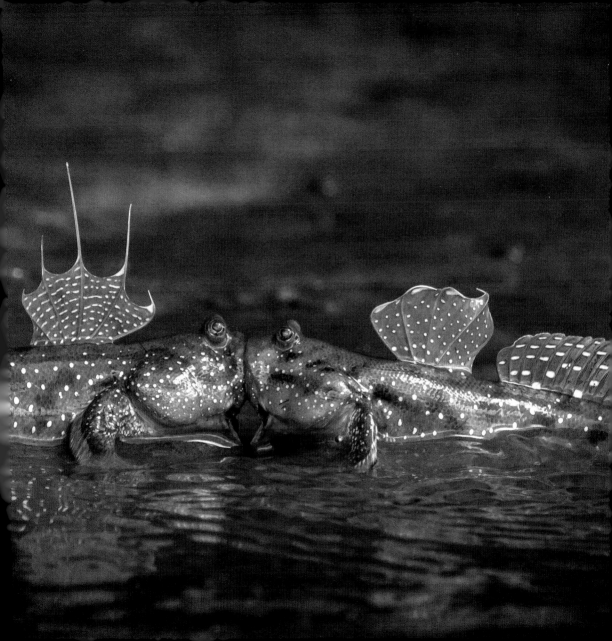

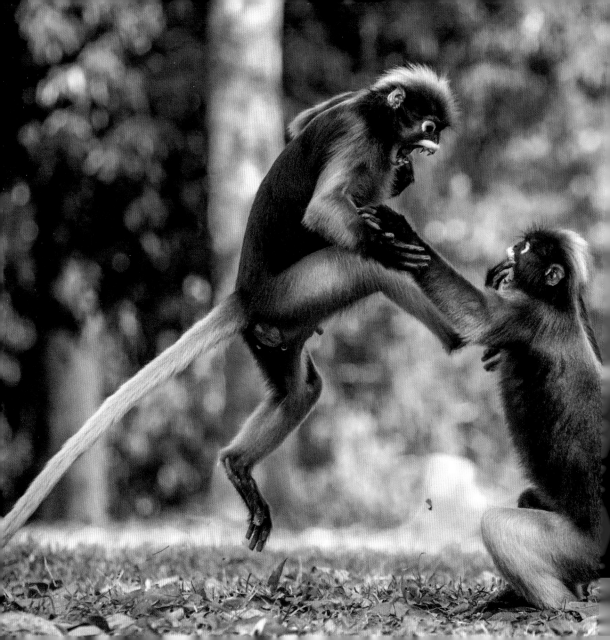

ANIMALS: Spectacled Langurs

LOCATION: KAENG KRACHAN NATIONAL PARK, THAILAND

'This is Sparta!' – two spectacled langur monkeys re-enact an iconic moment from the film *300*.

PHOTOGRAPHER: Sergey Savvi

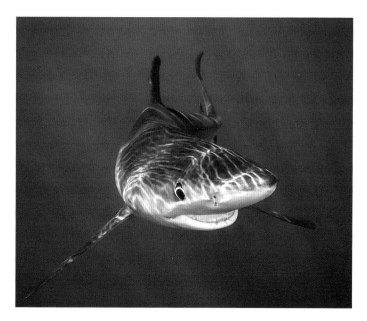

ANIMAL: Blue Shark
LOCATION: RHODE ISLAND, USA
Bloody Spielberg gives us sharks a really bad name, but we're a friendly bunch really!
PHOTOGRAPHER: Tanya Houppermans

ANIMAL: Burrowing Owl
LOCATION: SALTON SEA, CALIFORNIA, USA
'Peek-a-boo!' says this playful burrowing owl.
PHOTOGRAPHER: Shane Keena

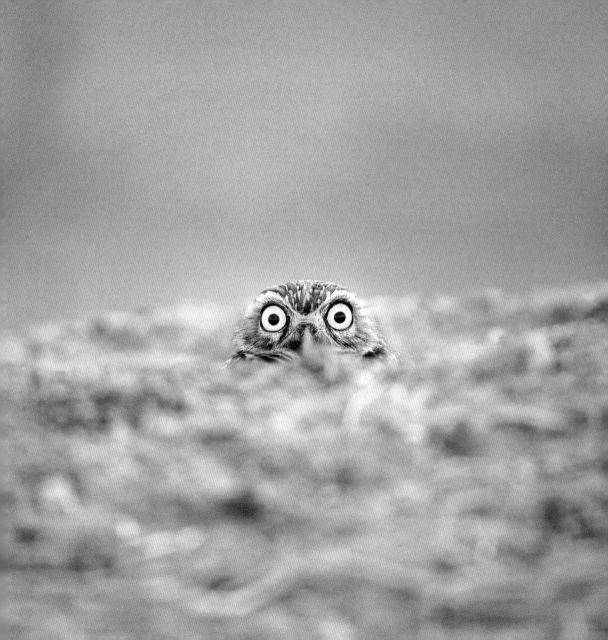

ANIMAL: Polar Bear

LOCATION: CHURCHILL, MANITOBA, CANADA

Ok, I grant you that the circumstantial evidence is against me, but I definitely did not throw that snowball.

PHOTOGRAPHER: Simon Gee

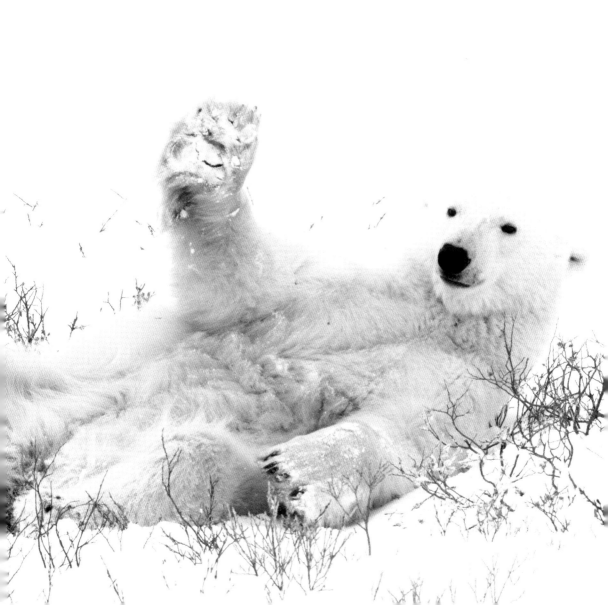

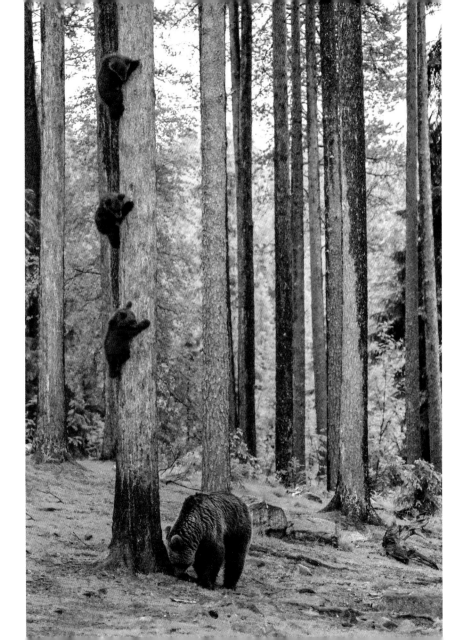

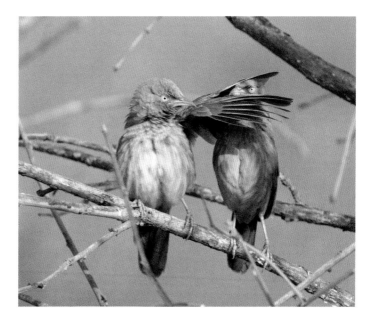

ANIMALS: Jungle Babbler

LOCATION: GIR FOREST NATIONAL PARK, GUJARAT, INDIA

You're not old enough to see what's going on over there. One day I'll teach you about the birds and the bees...

PHOTOGRAPHER: Anuj Raina

ANIMALS: Brown Bears

LOCATION: RUHTINANSALMI, FINLAND

Quick, hide! Mum's back from the parent-teacher meetings...

PHOTOGRAPHER: Valtteri Mulkahainen

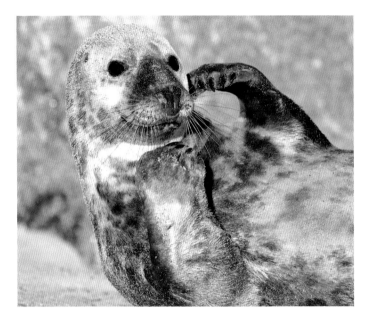

ANIMAL: Grey Seal
LOCATION: WINTERTON, NORFOLK, UK
Never has the expression 'southpaw' been more appropriate
than to describe this grey seal pugilist.
PHOTOGRAPHER: James Yaxley

ANIMAL: Fox Squirrel
LOCATION: CALIFORNIA, USA
Being served breakfast in bed really is a joy sometimes…
PHOTOGRAPHER: Barbi Lawrence

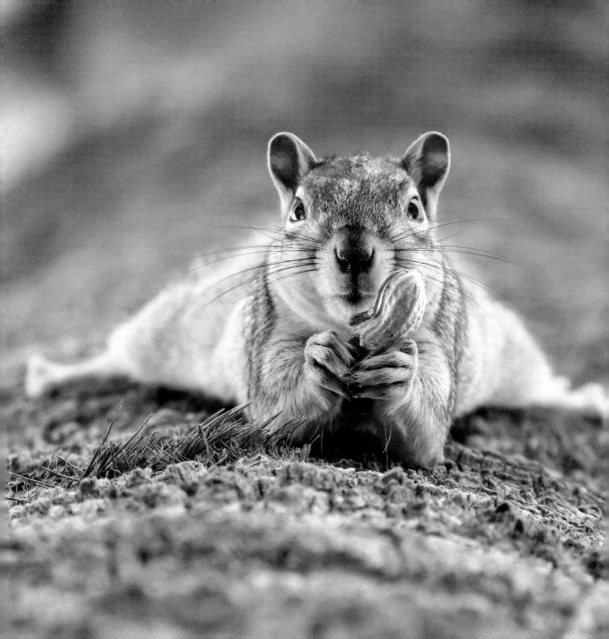

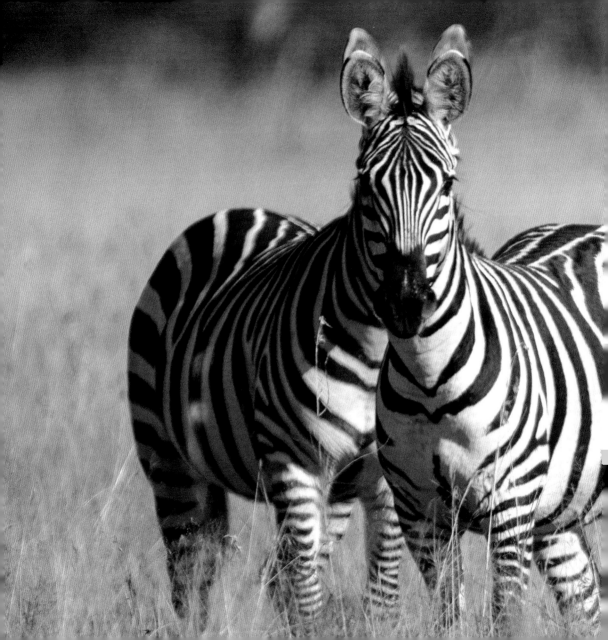

ANIMALS: Zebras

LOCATION: SERENGETI, TANZANIA

The rare eight-legged, two-bodied zebra. Confusing lions since 1985.

PHOTOGRAPHER: Chris Atkins

ANIMAL: Polar Bear

LOCATION: SVALBARD, NORWAY

Ha – now Attenborough will see how he likes it!

PHOTOGRAPHER: Roie Galitz

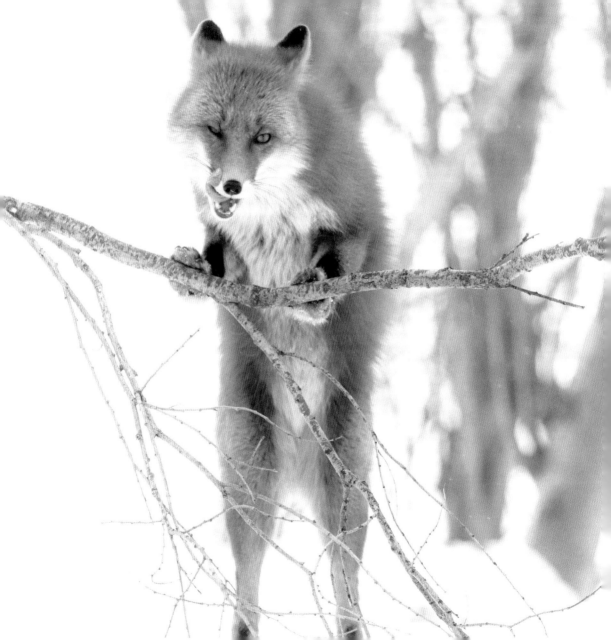

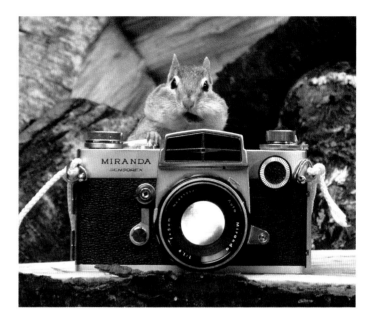

ANIMAL: Chipmunk

LOCATION: VERMONT, USA

Alvin takes a cheeky photo of Simon and Theodore on holiday.

PHOTOGRAPHER: Douglas Steward

ANIMAL: Red Fox

LOCATION: KAMCHATKA, RUSSIA

This red fox has been working on his smoulder all day. Perhaps the lip-licking is a step too far though.

PHOTOGRAPHER: Denis Budkov

ANIMALS: Cheetahs

LOCATION: KALAHARI, SOUTH AFRICA

The downside of being the faster runner…

PHOTOGRAPHER: Elaine Kruer

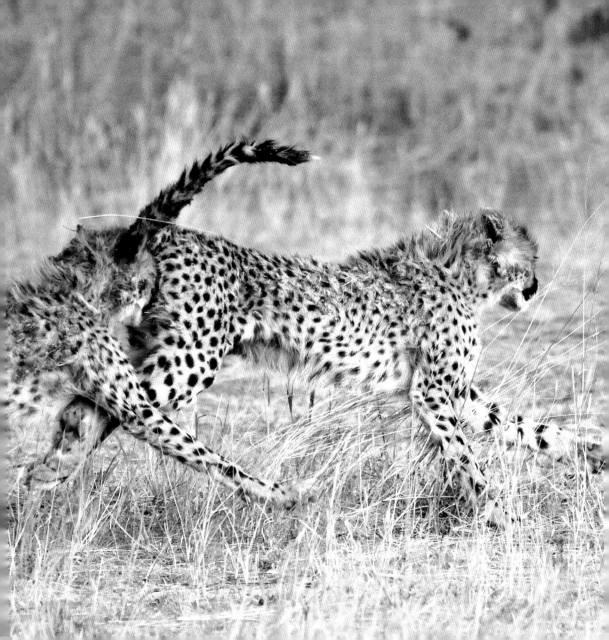

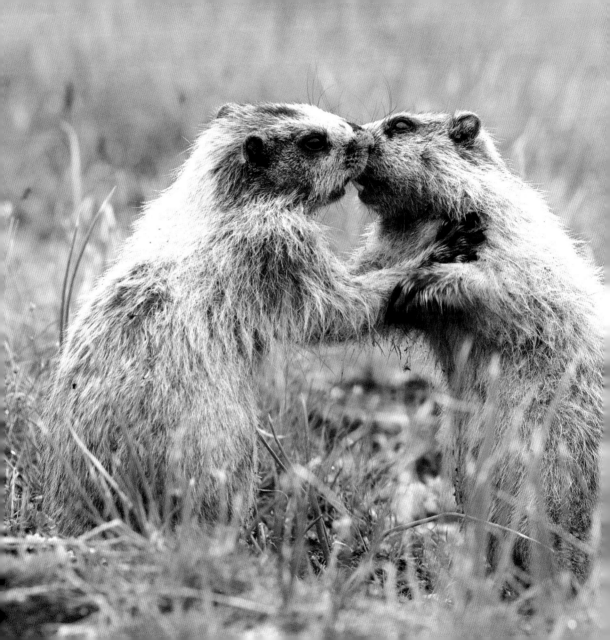

ANIMALS: Hoary Marmots

LOCATION: GLACIER NATIONAL PARK, MONTANA, USA
A high-risk kiss between hoary marmots – those teeth will do some serious damage!

PHOTOGRAPHER: Gian Mario Zaino

ANIMALS: Brown Bears

LOCATION: MACEDONIA

A beard scratch – one of the blissful bear necessities of life.

PHOTOGRAPHER: Goran Anastasovski

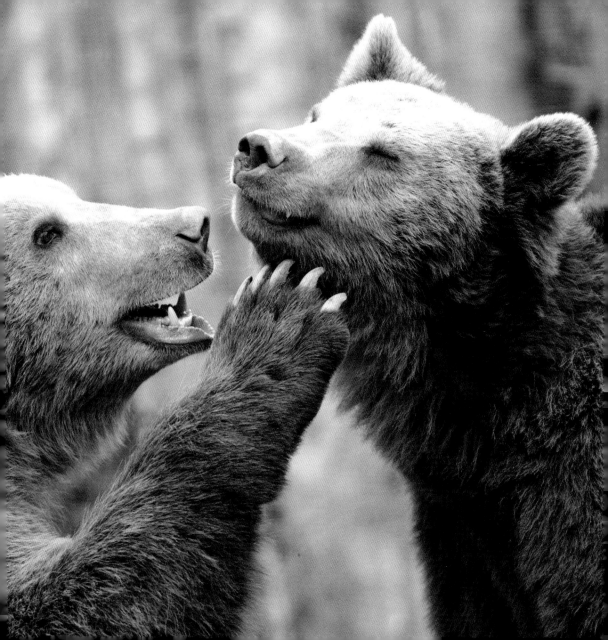

ANIMALS: Steller's Sea Eagle and Crow
LOCATION: JAPAN
This is taking the expression 'chasing tail' a little far.
PHOTOGRAPHER: Isobel Wayrick

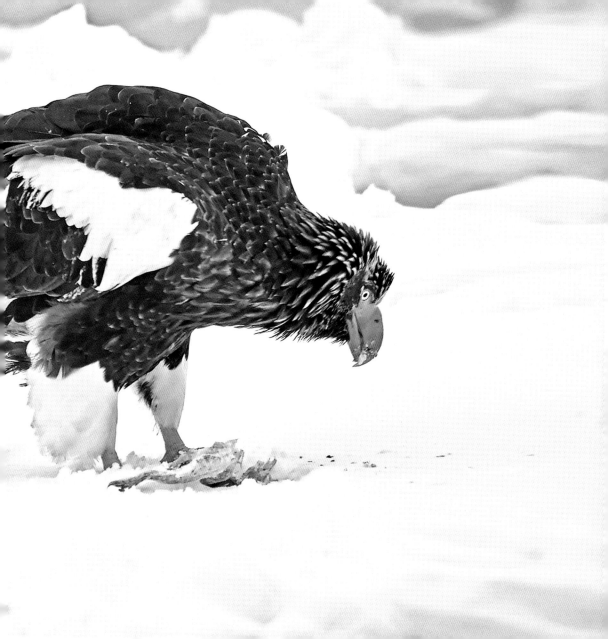

ANIMALS: Japanese Macaques

LOCATION: NAGANO, JAPAN

They don't have tools or novocaine, and their hand hygiene is
a little suspect, but at least monkey dentists do home visits.

PHOTOGRAPHER: Jack Reynolds

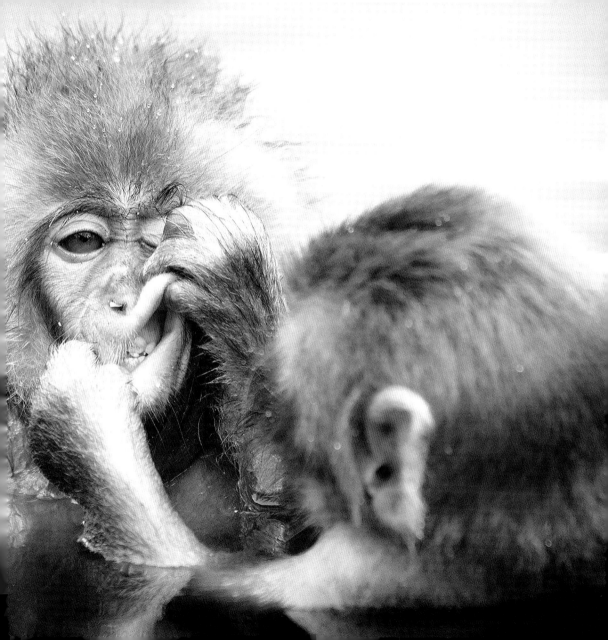

ANIMALS: King Penguins

LOCATION: SOUTH GEORGIA ISLAND

If you can keep your head when all about
you are losing theirs and blaming it on you...
you'll be a penguin, my son!

PHOTOGRAPHER: Jackie Downey

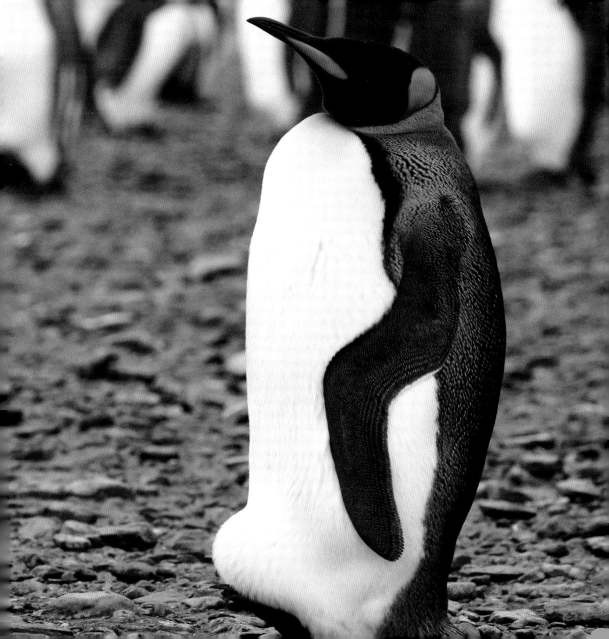

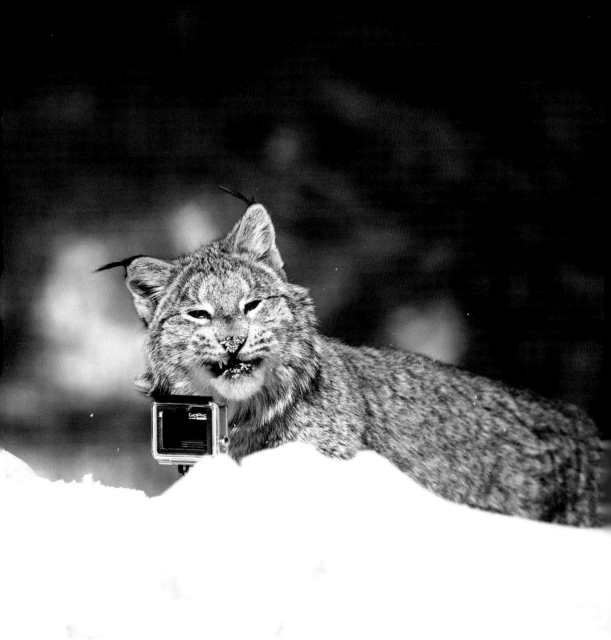

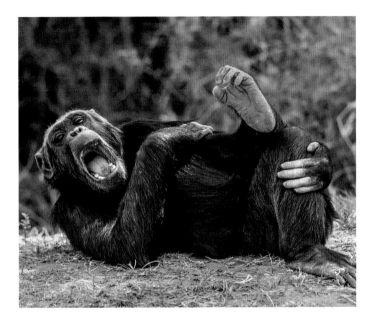

ANIMAL: Chimpanzee
LOCATION: KENYA
If ever there was a visual representation of the abbreviation 'ROFL', then this is it.
PHOTOGRAPHER: Manoj Shah

ANIMAL: Canada Lynx
LOCATION: NORTH BAY, ONTARIO, CANADA
I think they call this selfie pose the Lynx Effect.
PHOTOGRAPHER: Megan Lorenz

ANIMAL: Algerian Hedgehog

LOCATION: TEGUISE, LANZAROTE

As happy as a hedgehog in a red cosco field. This expression never quite caught on in the way that 'as happy as a pig in ****' did.

PHOTOGRAPHER: Manuel Ángel Gallego de Prada

TAKE ACTION FOR ANIMALS

RESOURCES

Not all of us get to see wildlife in the wild where they rightfully belong, but you can help animals no matter where you are. Here are a few things you can do to help our planet and its wild inhabitants:

1. Get in touch with your local MP and council. Tell them how you want them to vote on conservation, animal protection, and climate change bills. Representatives listen to their constituents, so make your voice heard. Call, email, or even better, write a letter.

2. Sign up for an email list to stay informed about the issues and learn about proposed legislation that needs your voice. We recommend Born Free at www.bornfree.org.uk.

3. Use social media. Follow and support wildlife conservation organisations to stay up to date on new legislation, current events, and on what is happening in the field. Show your support by becoming an ambassador and sharing their posts with your friends.

4. Donate. Put some of your hard work toward preserving our planet and our wildlife, so future generations will be able to see wildlife in the wild. You want problems solved,

and there are experts who are working to solve them, but they can't do it without funding. Also, look further than what you see on TV. Bigger isn't always better; many small organisations are making a huge impact and putting your donations to work for animals. And, remember, no donation is too small. The most important thing is to give something.

5. Recycle. Yes, do it! It really makes a difference, sometimes you may not think it does but if we all start doing it then it really will start to help our planet. Also try to limit your weekly rubbish, which isn't recyclable. Give your household a single container and try and stay within that for the week. If you go over, work out why and try and change where you shop or what you buy. We are trying it and it can be hard, but it's definitely doable.

6. Loo Water. Don't always flush! I know, you buy a funny animal book and now you're getting asked to leave wee hanging around, but check this out… if you have an older loo, then the average person is using 70 litres a day flushing, that's 4,550,000,000 litres of water a year for the Great British Public on the loo and that doesn't include showers, baths, dishwashers and washing machines. Yikes. OK so how you can genuinely help:
A. Buy an ULF Toilet, it's super low water usage and great.
B. Don't flush what doesn't really need flushing, if you get my gist…?
C. Shorter showers, say 5 mins max?

It's a start and do let us know if you have other brilliant ideas.

We love Born Free. We know them and they use their hard-earned resources extremely well and have made a genuine difference to wildlife across the planet. Both Tom and I have first-hand experience of it.

You can give at www.bornfree.org.uk/donate.

ACKNOWLEDGEMENTS

It would be difficult to know where to start these acknowledgements if Paul and Tom had had much support. Sadly they did this all on their very own, struggling through the multi-disciplined requirements of running a photography competition much like a Cheetah struggles to abide by the recent 40 mph speed limit set on his territory.

Seriously, however, we are joking. We are over the moon that the Comedy Wildlife Photography Awards has taken off with such aplomb since its inception just two years ago. For that success, we would like to thank several people.

Our judges, Kate Humble, Hugh Dennis, Will Travers, Will Burrard-Lucas, Oliver Smith, Simon Pollock, Andrew Skirrow and Ashley Hewson. The Magnificent Eight, all individually bringing their own specialism, skill and insight to the judging process, and all elevating the competition to a level it would have struggled to achieve had it been left in our own shaky hands. Thank you, it really has been a pleasure, and we look forward to many more years working with you.

Our sponsors and partners: The Born Free Foundation, Amazing Internet, Alex Walker Serian, Spectrum Photo, Think Tank, and Affinity. The Magnificent Six this time, and utterly

invaluable to the success of this photographic competition. To be able to offer the prizes we do, the exhibition and the website – each part has been a major reason for helping reach so many people and increase awareness of these animals. Thank you to you all for what you have done and what you continue to do.

Our literary agent Natalie Galustian, a fantastic source of knowledge and direction who continues to juggle Paul and Tom's myriad character flaws and help get the show on the road. Which very smoothly leads us onto thanking our publisher, Joel Simons at 535 and Blink Publishing, for performing a very similar role to Natalie's!

And finally, though by no means least, to our families – The Pooch, Tommy & Sammy on one side, and Kate, JoJo and Finn on the other side. They have been so tolerant of our late nights, early mornings, and general disappearance acts (to play golf) and not once have they shown any interest, exasperation with or doubt in our project. For that we owe them a lot more than we can ever pay back. Thank you.

With much love to all of you,
Paul and Tom.

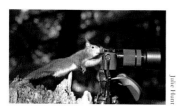

Julie Hunt

ABOUT THE CREATORS

PAUL JOYNSON-HICKS is a wildlife photographer. He lives in Arusha, Tanzania with his Mrs, (aka The Pooch) and his two small boys (aka the Bograts), and his Springers. He loves being in the bush and taking pictures. He was awarded an MBE for charitable work in East Africa over the last 25 years, not for his photography. But we are sure that if he perseveres he might win something one day.

Having spent the first part of his professional life working in financial services in London, **TOM SULLAM** realised the error of his ways to quit everything in order to pursue a career in photography. He won the prestigious Fuji Photographer of the Year award, along with the One Vision prize. He recently moved with his family to Tanzania where the wilds of African landscapes have provided yet another challenge.

IN PARTNERSHIP WITH THE BORN FREE FOUNDATION

The Comedy Wildlife Photography Awards are proud to support Born Free, an international wildlife charity founded by Virginia McKenna, Bill Travers and their eldest son, Will Travers, following Bill and Virginia's starring roles in the classic film *Born Free*. The charity works tirelessly to ensure that all wild animals, whether living in captivity or in the wild, are treated with compassion and respect and are able to live their lives according to their needs. Born Free opposes the exploitation of wild animals in captivity and campaigns to Keep Wildlife in the Wild. It promotes Compassionate Conservation to enhance the survival of threatened species in the wild and protect natural habitats, while respecting the needs and safeguarding the welfare of individual animals.

Find out more and get involved at www.bornfree.org.uk.

Amazing Internet is a leading provider of websites for photographers and other visual artists. Creators of the original and best template-based website system for photographers: portfolioseries.co.uk

Fast, smooth and powerful, Affinity Photo pushes the boundaries for professional photo editing on Mac, Windows and iPad.

Think Tank produces original innovative products that can handle all types of conditions experienced during the photographic process. Our philosophy is simple: Our products should help photographers "Be ready for the moment" TM

Alex Walker's Serian is a charismatic collection of exclusive and intimate safari camps in the prime wildernesses of Kenya and Tanzania. We operate and outfit safaris, and our focus is on offering you access to the magic of the bush in a rich variety of ways. www.serian.com

Spectrum is a longstanding professional imaging lab specialising in high quality fine art and photographic printing, as well as archival mounting. www.spectrumphoto.co.uk

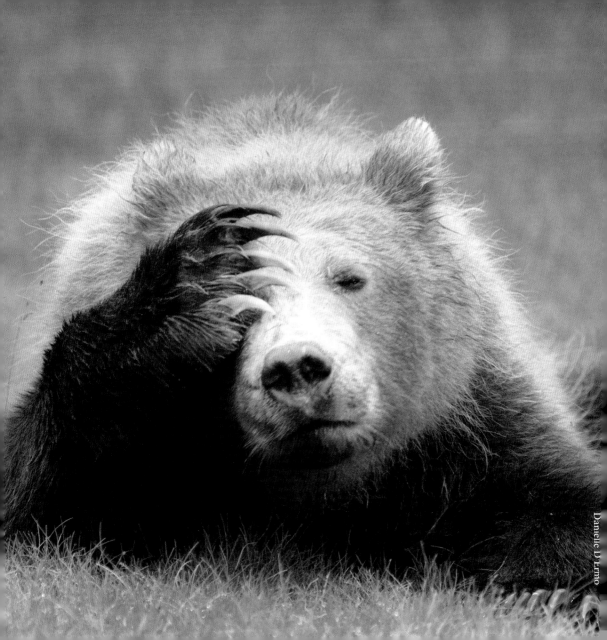